THE GILDED AGE

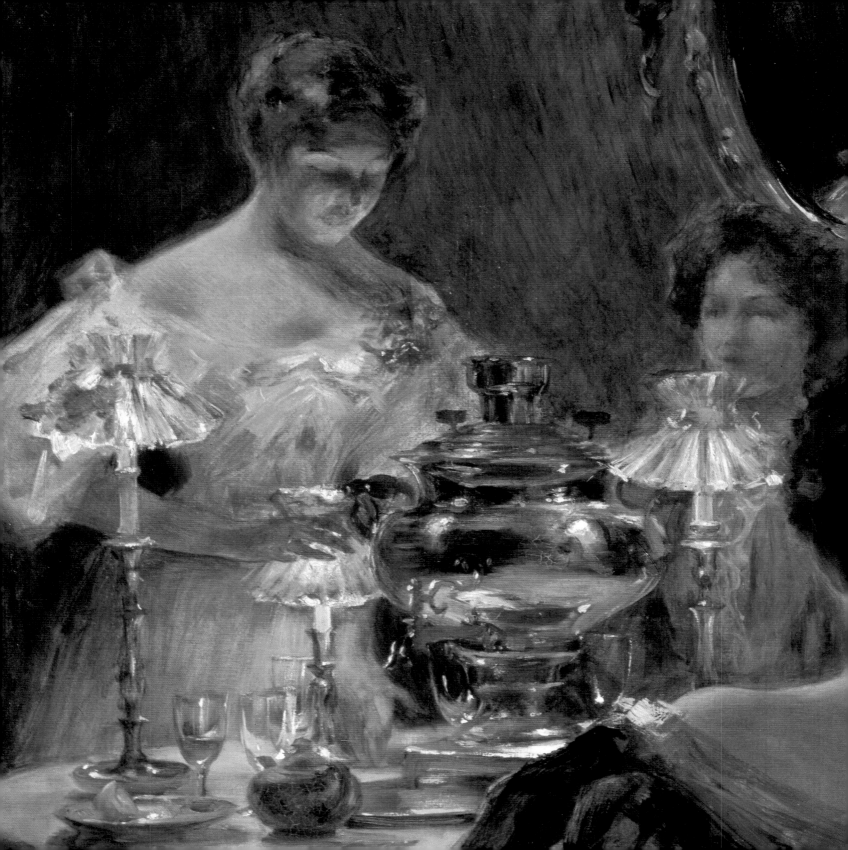

THE GILDED AGE

AGE

Treasures from the
Smithsonian American Art Museum

Elizabeth Prelinger

Watson-Guptill Publications/New York

Smithsonian American Art Museum

The Gilded Age: Treasures from the
Smithsonian American Art Museum

By Elizabeth Prelinger

Chief, Publications: Theresa Slowik
Designers: Steve Bell, Robert Killian
Editor: Mary J. Cleary
Editorial Assistant: Tami Levin

Library of Congress Cataloging-in-Publication Data

National Museum of American Art (U.S.)
 The Gilded Age : treasures from the Smithsonian
American Art Museum / Elizabeth Prelinger.
 p. cm.
Includes index.
 ISBN 0-8230-0192-X
 1. Art, American—Exhibitions. 2. Art, Modern—
19th century—United States—Exhibitions. 3. Art,
Modern—20th century—United States—Exhibi-
tions. 4. Art—Washington (D.C.)—Exhibitions. 5.
National Museum of American Art (U.S.)—Exhibi-
tions. I. Prelinger, Elizabeth. II. Title.
 N6510 .N374 2000
 709'.73'074753—dc21
 99-050977

Printed and bound in Italy

First printing, 2000
2 3 4 5 6 7 8 9 / 07 06 05 04 03 02 01 00

Cover: John Singer Sargent, *Elizabeth Winthrop
Chanler* (detail), 1893, oil. Smithsonian American Art
Museum, Gift of Chanler A. Chapman (see page 82).

Frontispiece: Irving R. Wiles, *Russian Tea* (detail),
about 1896, oil. Smithsonian American Art Mu-
seum, Gift of William T. Evans (see page 108).

The Gilded Age is one of eight exhibitions in *Treasures to Go*, from the Smithsonian American Art Museum, touring the nation through 2002. The Principal Financial Group® is a proud partner in presenting these treasures to the American people.

Foreword

Museums satisfy a yearning felt by many people to enjoy the pleasure provided by great art. For Americans, the paintings and sculptures of our nation's artists hold additional appeal, for they tell us about our country and ourselves. Art can be a window to nature, history, philosophy, and imagination.

The collections of the Smithsonian American Art Museum, more than one hundred seventy years in the making, grew along with the country itself. The story of our country is encoded in the marvelous artworks we hold in trust for the American people.

Each year more than half a million people come to our home in the historic Old Patent Office Building in Washington, D.C., to see great masterpieces. I learned with mixed feelings that this neoclassical landmark was slated for renovations. Cheered at the thought of restoring our magnificent showcase, I felt quite a different emotion on realizing that this would require the museum to close for three years.

Our talented curators quickly saw a silver lining in the chance to share our greatest, rarely loaned treasures with museums nationwide. I wish to thank the dedicated staff who have worked so hard to make this dream possible. It is no small feat to schedule eight simultaneous exhibitions and manage safe travel for more than five hundred precious artworks for more than three years, as in this *Treasures to Go* tour. We are indebted to the dozens of museums around the nation, too many to name in this space, that are hosting the traveling exhibitions.

The Principal Financial Group® is immeasurably enhancing our endeavor through its support of a host of initiatives to increase national awareness of the *Treasures to Go* tour so more Americans than ever can enjoy their heritage.

The phrase "gilded age" entered our vocabulary when Mark Twain and Charles Dudley Warner published a novel about "the golden road to fortune" in 1873, and the period from the 1870s through the 1920s has become identified with that name. Internationally recognized portrait painters such as John Singer Sargent, Irving Wiles, and Cecilia Beaux found ready patrons among the new industrialists of the time, while John La Farge and Augustus Saint-Gaudens provided luxurious art for their homes.

A fascination with foreign travel and exotic cultures is reflected in works by Louis Comfort Tiffany, Frederick Arthur Bridgman, and Henry Ossawa Tanner, who depicted Middle Eastern and Egyptian scenes. Idealistic longings and visionary themes are also expressed in the Renaissance-inspired paintings of Abbott Thayer and in the refined vision of Albert Pinkham Ryder. The elemental drama of nature is captured in rugged landscapes by Winslow Homer.

The Smithsonian American Art Museum is planning for a brilliant future in the new century. Our galleries will be expanded so that more art than ever will be on view, and in an adjacent building, we are opening a new American Art Center—a unique resource for information on America's art and artists, staffed for public use. We are also planning new exhibitions, sponsoring research, and creating educational activities to celebrate American art and understand our country's story better.

Elizabeth Broun
Director
Smithsonian American Art Museum

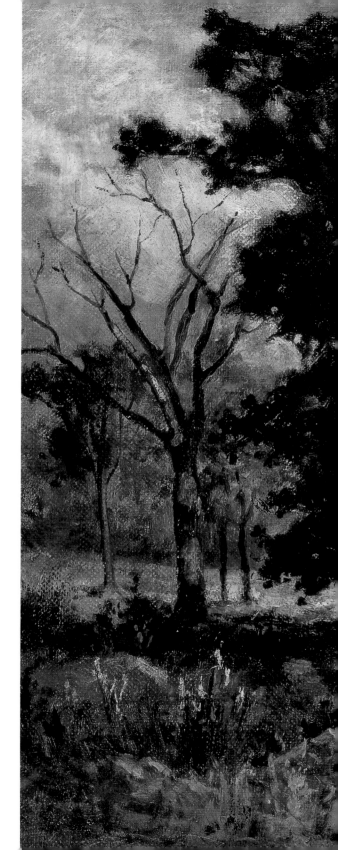

EDWARD MITCHELL BANNISTER

1828–1901

Tree Landscape

1877, oil
51 x 76 cm
Smithsonian
American Art
Museum, Gift of
Melvin and H. Alan
Frank from the
Frank Family
Collection

In this painting, trees are the protagonists. Silhouetted against the sky, they tower proudly over the land. Bannister's landscape reveals his sensitivity to the rustic poetry of nature and his aim as an artist to achieve the "absolute idea of perfect harmony."

Born in Canada, Bannister was active in Boston's African American abolitionist circles in the 1850s and 1860s before moving to Providence, Rhode Island, after the Civil War. Although his formal training was limited, he skillfully used his palette and expressive brushwork, demonstrating his awareness of the French landscape painters who worked in the small village of Barbizon. In 1876, the year before he painted *Tree Landscape*, Bannister won a silver medal at Philadelphia's Centennial Exhibition— the first black artist to be so honored.

PAUL WAYLAND BARTLETT

1865–1925

Bohemian Bear Tamer

modeled 1887, bronze
44.6 x 21.6 x 27.3 cm
Smithsonian
American Art
Museum, Gift of
Mary O. Bowditch

An expatriate living in France, the twenty-year-old Bartlett began this ambitious work in 1885 and two years later submitted the original plaster to the Salon exhibition in Paris. When the plaster won an honorable mention, the sculptor proceeded to have the work cast into the bronze version seen here. The dynamic group includes the bear tamer, probably a Gypsy from Bohemia in Central Europe, his crop concealed behind his back, who snaps his fingers for the bear cub to stand on his hind legs. The attention to anatomy, fur, and facial expressions, and the skill in capturing movement and emotion, reveal the influence of Bartlett's traditional French training.

More than just a glimpse of a circus act, this is a sculpture of ideas. While other contemporary animal sculptures implied that Darwinian brute strength prevails in the race for survival, Bartlett emphasized a caring interaction between human and animal. Instead of violent domination, the tamer exercises intellect, reason, and benevolence over nature. The cub's poignant pose recalls our biological proximity to the animal kingdom, while also reassuring Bartlett's generation, anxious about the implications of Darwin's theories, of its superiority.

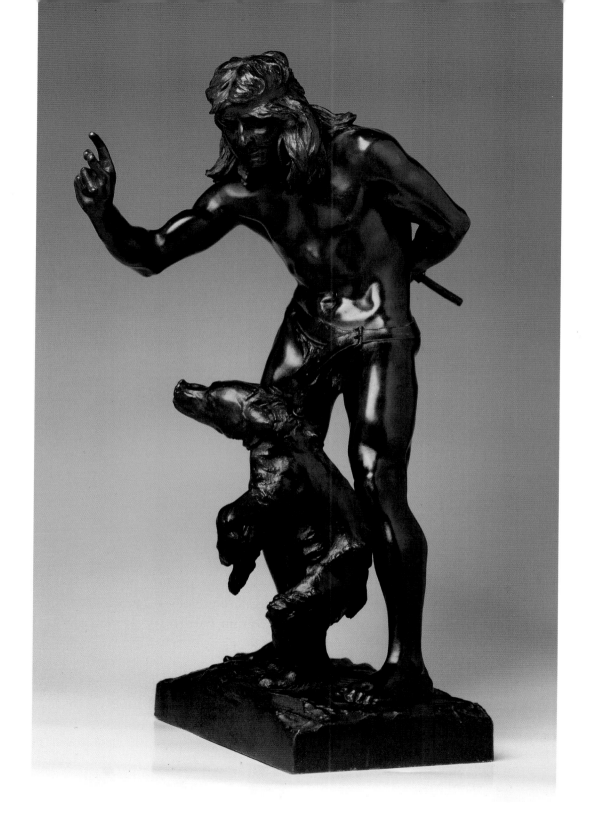

CECILIA BEAUX

1855–1942

Man with the Cat (Henry Sturgis Drinker)

1898, oil
121.9 x 87.8 cm
Smithsonian
American Art
Museum, Bequest of
Henry Ward Ranger
through the National
Academy of Design

Gazing at Beaux's vivid portrait of her brother-in-law Henry Sturgis Drinker, we understand a colleague's appraisal of her as "not only the greatest living woman painter, but the best that has ever lived." Like the painters Mary Cassatt and Thomas Eakins, Beaux was born in Philadelphia and specialized in portraits, and this has been considered her finest. At the time of the sitting, Drinker was in his late forties, a corporate lawyer for a railroad company who later became president of Lehigh University. With sweeping strokes of lush oil paint, the artist animated the sitter's cream-colored suit and the soft fur of the ginger cat that purrs contentedly in his lap. Lemony light streams in from the window at left, illuminating the rippled patterns of pigment in Drinker's jacket, head, and hands.

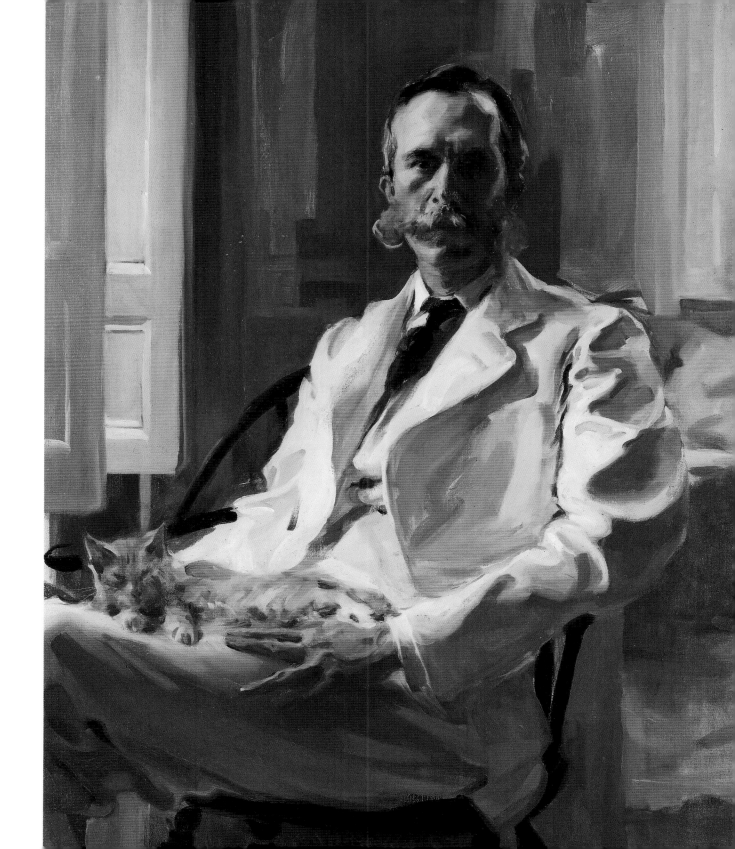

FRANK W. BENSON

1862–1951

Summer

1890, oil

127.1 x 101.6 cm

Smithsonian

American Art

Museum, Gift of

John Gellatly

Benson probably used his wife Ellen as the model for this statuesque woman, whose monumentality recalls the nymphs of Botticelli. Clad in flowing white and draped with a billowing shawl of pastel pinks, blues, yellows, and greens, this secular angel glides toward us through the breezy river landscape. Framed by trees and haloed by fluffy clouds, Summer reaches out with delicate fingers to grasp a blooming flower.

In 1896 this grand canvas won the Shaw Fund Prize at the Society of American Artists exhibition. Critics, however, voiced mixed opinions of its merit. One writer observed she was not a goddess, but rather "simply a charming woman." In his review of the exhibition, critic Royal Cortissoz mused, "there is no glamour of romance flung about her," but nevertheless acknowledged, "it is a good picture." The figure's meditative expression creates a sense of melancholy at odds with a summer's day, rendering the image enigmatic, decorative but unresolved.

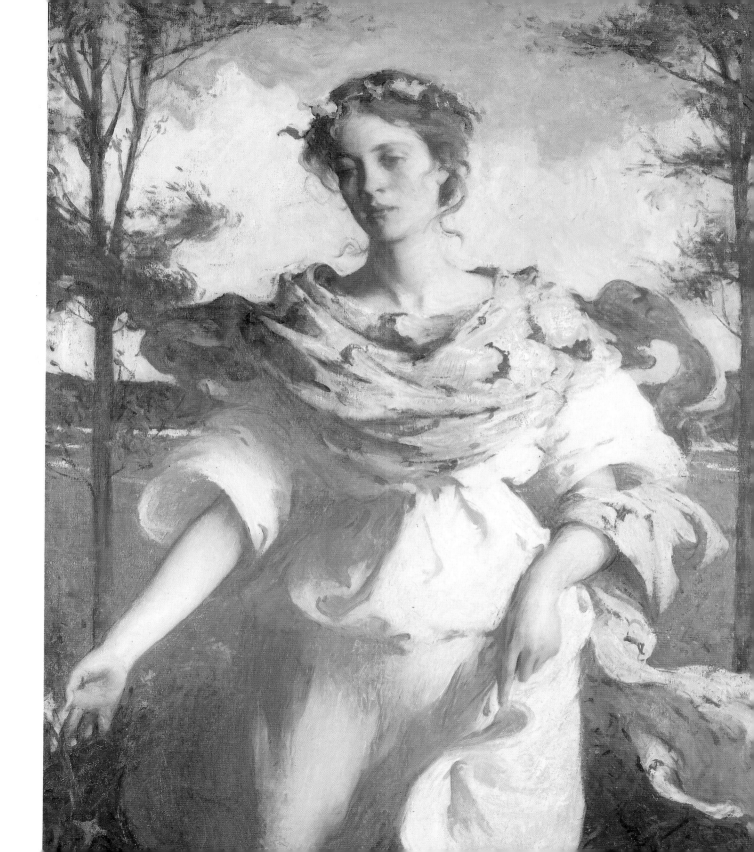

RALPH ALBERT BLAKELOCK

1847–1919

Moonlight, Indian Encampment

1885–89, oil
68.8 x 86.8 cm
Smithsonian
American Art
Museum, Gift of
John Gellatly

One of the most mysterious nineteenth-century artists, Blakelock worked his obsessive painterly magic in a world of shadows and indeterminacy. He traveled to the West in 1869 and again in 1872 to make drawings of such Native American life as still existed and based a host of scenes such as this one on his sketches. Unlike the heroic panoramas of the West by Albert Bierstadt and Thomas Moran, which were intended to amaze awestruck viewers, this atmospheric picture quivers on the canvas like a dream. The dark, densely painted foreground describes canoes, a glowing campfire, teepees, and the lacy trees that form spiky patterns against the heavens. Earthly silence becomes unearthly. Not so much a record of rapidly changing Native American culture, this image is instead a mood poem from the mind and heart of a painter who would, by the end of his life, endure an agonizing descent into madness.

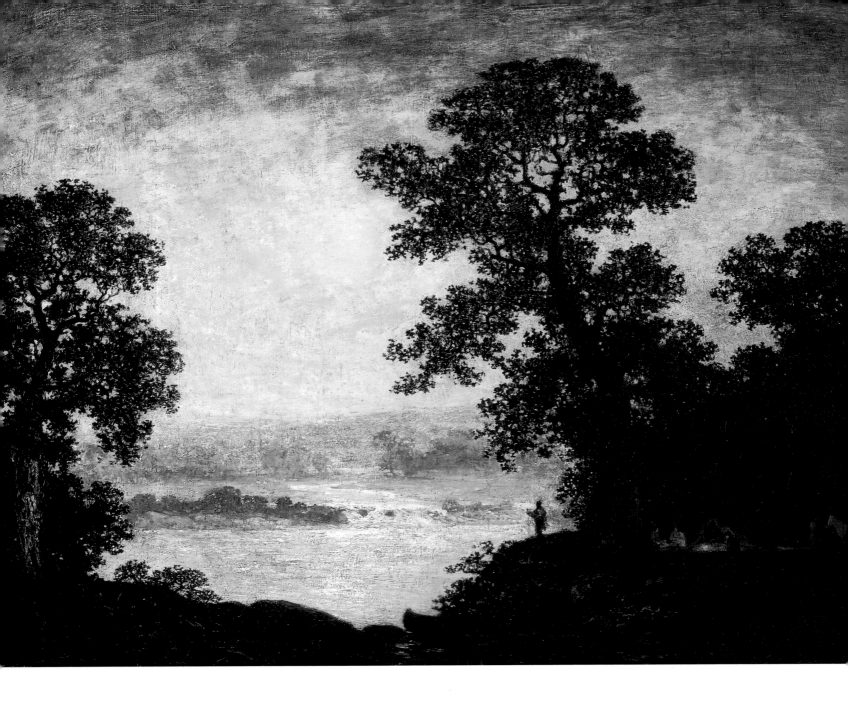

FREDERICK ARTHUR BRIDGMAN

1847–1928

Oriental Interior

1884, oil
70.2 x 111.8 cm
Smithsonian
American Art
Museum
Museum purchase
made possible by
the Pauline Edwards
Bequest

Shafts of blinding hot desert light infiltrate the shadowy cool of a café interior in Biskra, Algeria, where clustered figures converse. In the center, illuminated by a skylight, a card-playing couple lends its attention to a flute player. No respectable Arab woman would enter such a public place, so the pink-clad, bejeweled female suggests the paid assignation to come, adding a hint of eroticism and danger to the scene. So vivid is Bridgman's rendering that one can sniff, as he did, "perfumes of musk, tobacco, orange-blossoms, coffee, hashish."

The town of Biskra was the last safe outpost for Westerners in hostile Algeria; French émigrés had settled it after the Franco-Prussian War. Bridgman, an American expatriate living in France, traveled to Egypt and Algeria in the 1870s, bringing back scores of drawings and oil sketches, and a collection of decorative objects, fabrics, and jewelry. With these, the painter outfitted his two Parisian studios, using them in pictures for decades to come. When Bridgman returned to America for a brief visit in 1881, carrying with him 320 paintings with Eastern themes, the exhibition and subsequent sale were astonishingly successful; the exoticism and sheer luxury of scenes such as this complemented the glitter of the Gilded Age.

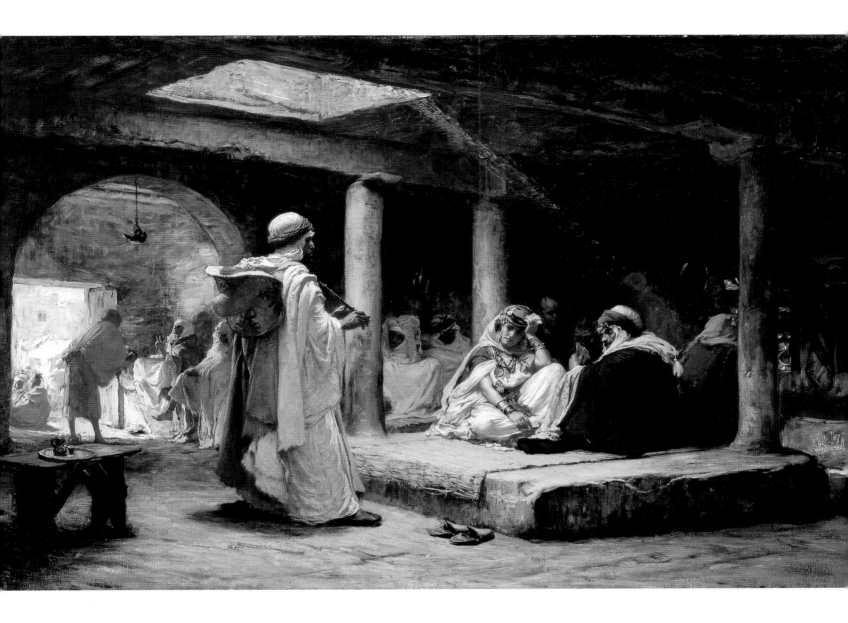

THOMAS WILMER DEWING

1851–1938

A Reading

1897, oil
51.3 x 76.8 cm
Smithsonian
American Art
Museum, Bequest of
Henry Ward Ranger
through the National
Academy of Design

THOMAS WILMER DEWING

1851–1938

Music

about 1895, oil
108 x 91.4 cm
Smithsonian
American Art
Museum, Gift of
John Gellatly

Like many nineteenth-century artists, Dewing equated art with music. Through composition, color, and paint handling he evoked musical "harmonies." This connection reverberated in many aspects of his life; the critic Royal Cortissoz related that, when visiting Dewing, he "used to be charmed by the harp on the door which gave forth delicate music as the door was open and shut. That is what characterizes his art, an exquisite music."

To emphasize the idea of musical sounds through visual representation, Dewing intentionally left this image sketchy, suggestive, open to imaginative interpretation. Concerned with surface patterns, he posed the figure at right with the curvilinear grace of a personified G clef. Seated, plucking a mandolin, her companion draws forth caressing notes from the elongated instrument. Delicate, subtle shades evoke musical tonalities.

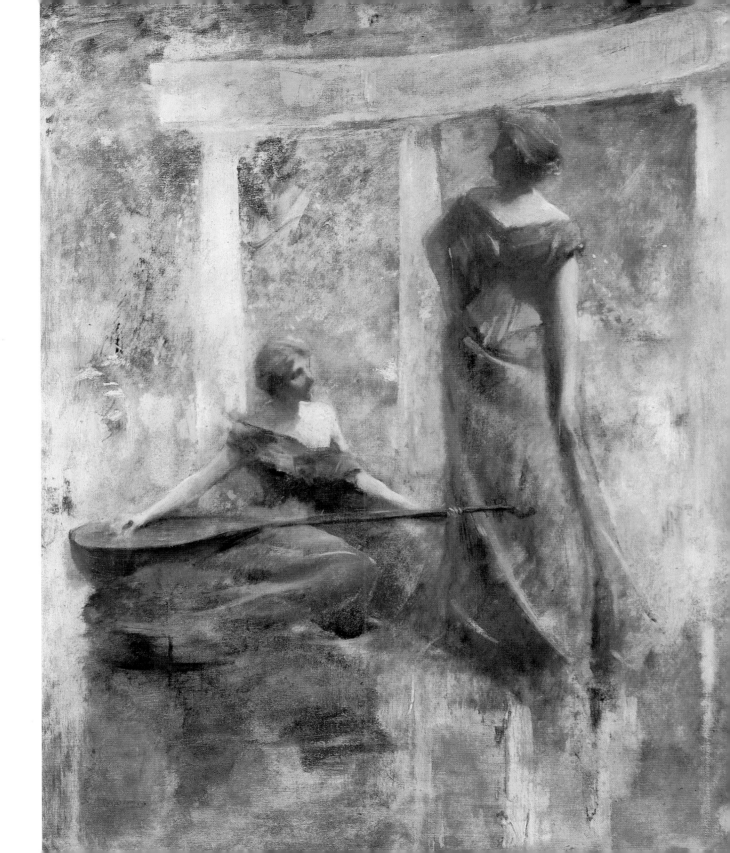

FRANK DUVENECK

1848–1919

Water Carriers, Venice

1884, oil
122.8 x 185.7 cm
Smithsonian
American Art
Museum, Bequest of
Rev. F. Ward Denys

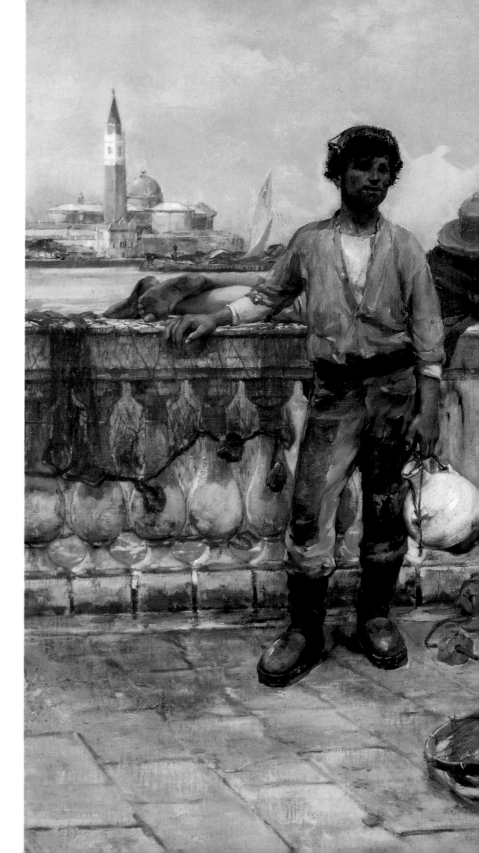

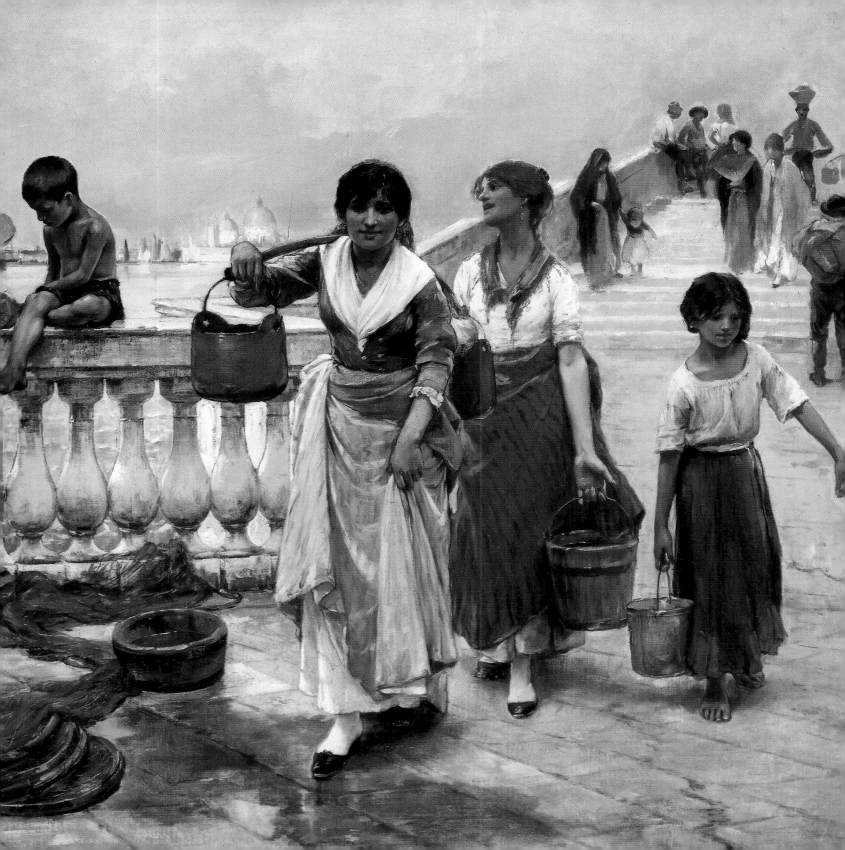

THOMAS EAKINS

1844–1916

William Rush's Model

(detail)

1908, oil

92.1 x 122.3 cm

Smithsonian

American Art

Museum, Gift of

Mr. and Mrs.

R. Crosby Kemper Jr.

Eakins's painting commemorates an earlier Philadelphia artist, William Rush (1756–1833), one of America's first professional sculptors and a pioneer in working from the nude model. In 1809 the Philadelphia City Council commissioned Rush to make a figure for a fountain in honor of the Schuylkill River. Over many years, Eakins memorialized Rush in a number of paintings of the artist's studio and his sessions working from the model, the moment portrayed here.

The subject held great significance for the painter's own life. A teacher at the Pennsylvania Academy of the Fine Arts for many years, Eakins ultimately lost his job for persisting in using nude models in his painting classes for women. In the Victorian era, his straightforward representations of the nude figure were considered dangerous to his female students and to society in general. Years after his dismissal, he remained true to his ideas, seen here in the unthinkable liberty he took in showing the model's pubic hair. Yet Eakins's steady confrontation with his subject matter has assured his status, along with Winslow Homer, as one of the greatest of all nineteenth-century American painters.

J. WILLIAM FOSDICK

1858–1937

Adoration of St. Joan of Arc

1896, fire-etched
wood relief
three panels, each:
278.8 x 125.7 cm
Smithsonian
American Art
Museum, Gift of
William T. Evans

A master craftsman, Fosdick made his three-paneled paean to St. Joan of Arc by a method called fire etching. Fashionable at the turn of the century, the art of "pyrography" was the medium of numerous decorative objects such as this, so-called poker pictures. The artist would burn the lines of the composition into wood with hot irons and then apply paint, gilding, even jewels to the surface.

A pioneer in the technique, Fosdick harbored a passion for medieval history. One of his favorite subjects, Joan of Arc, the warrior-martyr of fifteenth-century France, lent itself well to this craft-intensive medium. In the central panel, the virgin saint floats, transfigured, grasping a sword and a distaff. Above her, in the semicircle of light spanning the work, angels pray over St. Joan and the princes of France, who hoist rippling standards of king and country. Upon her breast, the white cross, symbol of France during the Hundred Years' War, forms the centerpiece of the work. Lilies refer to her purity. Below the shield, the saint's last words appear in French: "My last vows, my last thoughts are for my God, my Country and my King."

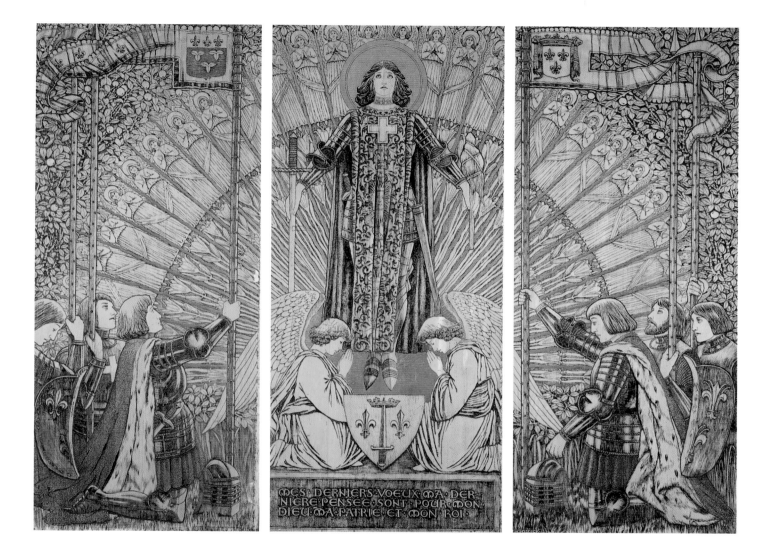

MES · DERNIERS · VOEUX · MA · DER-
NIERE · PENSEE · SONT · POUR · MON
DIEU · MA · PATRIE · ET · MON · ROI ·

J. BOND FRANCISCO

1863–1931

The Sick Child

1893, oil
81.1 x 121.8 cm
Smithsonian
American Art
Museum

This poignant scene portrays a bedridden child clutching a beloved toy, his medications on the night table. His mother knits at his side. Despite the light that streams over him from an unseen source at right, the prognosis remains in doubt.

For this "exceptionally fine salon picture," as a critic described it, Francisco chose a subject frequently rendered in the late nineteenth century. The century's end saw an epidemic of tuberculosis, perhaps the cause of the tragic moment depicted here. Francisco probably encountered the theme while studying music and art in Germany and France, but he may have chosen the subject for personal reasons. An undated newspaper article from about this time reports that the artist and his wife lost their three-year-old "flaxen-haired fairy" Yvette, whose death took "all the light and sweetness of life from the household." Although two more children would bless the family, Francisco abandoned figure painting, finding solace and his true mission as an artist in the glories of the California landscape.

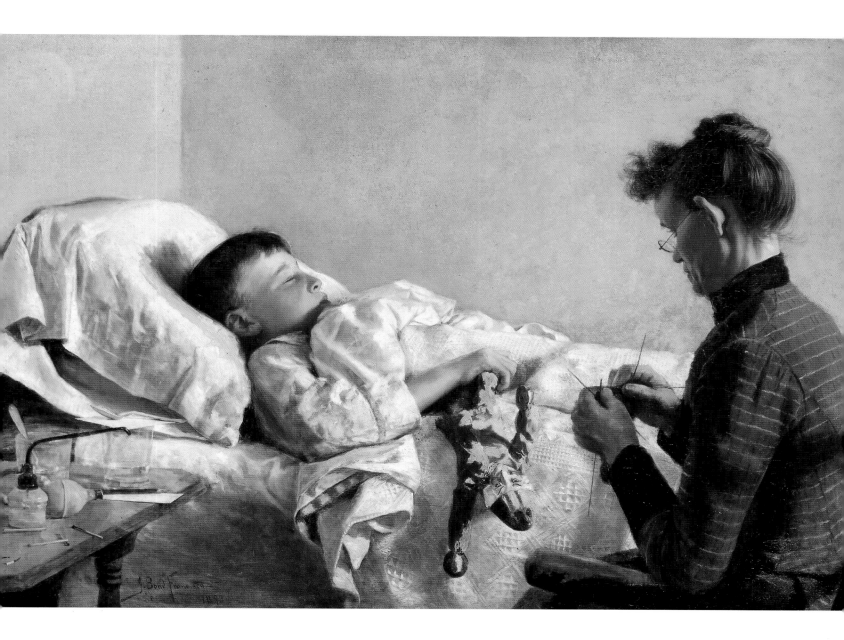

HENRY BROWN FULLER

1867–1934

Illusions

before 1901, oil
178.6 x 114.6 cm
Smithsonian
American Art
Museum, Gift of
William T. Evans

In *Illusions*, Fuller juxtaposed the themes of veneration of nature and aspiration to culture, the twin concerns of nineteenth-century American society. In the foreground, posed before an elegant balustrade, a child attempts to grasp a transparent sphere, symbol of illusions, which an allegorical female figure holds beyond his reach. Her draperies, along with the architecture, allude to the classicism of the Italian Renaissance, which many American painters of the century's end embraced as the apex of true civilization. Art and culture combine also in the distant silhouette of Mount Ascutney near Cornish, New Hampshire, where a colony of artists, including Thomas Dewing and Augustus Saint-Gaudens, built Italianate mansions surrounded by cultivated Italianate gardens.

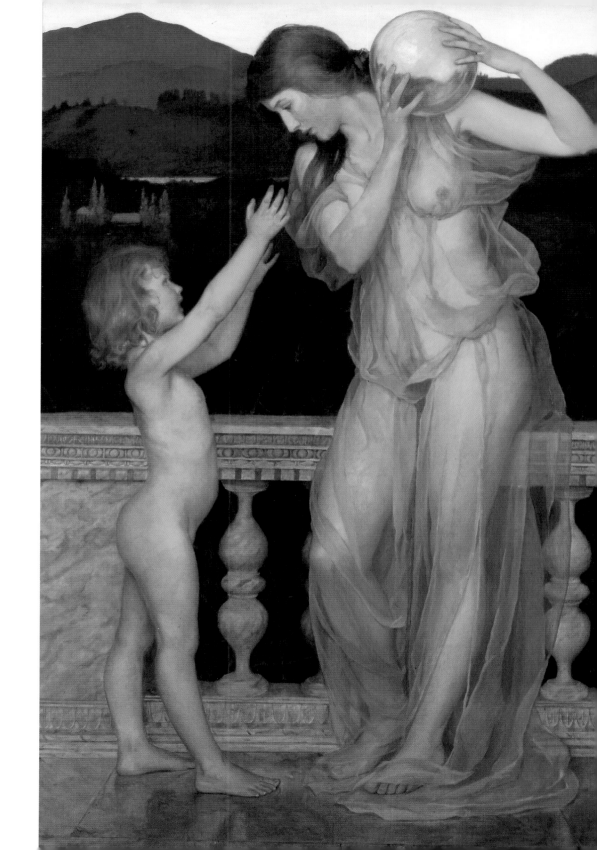

WALTER GAY

1856–1937

Novembre, Etaples

about 1885, oil
110.5 x 163.8 cm
Smithsonian
American Art
Museum

In *Novembre, Etaples,* Gay suggests the nobility as well as the travails of peasant life while avoiding being strident or saccharine. In this simple French scene, a lone figure hoes the household plot in the garden of a fine farmhouse, discernible at upper right. With impressionist touches and a palette of subdued hues, the painter evokes the quiet light of a November day and the tangled growth and modest bounty of the late harvest. Gay emphasizes the essential dignity of the woman as she works the land.

An expatriate who left Boston for Brittany, Gay began his career with genre scenes from eighteenth-century life, shifting in 1884 to the kind of realistic peasant picture seen here. He ultimately abandoned that subject matter as well, devoting himself in the last decades of his life to the elegant interiors that surrounded him in his château and in his Paris apartment.

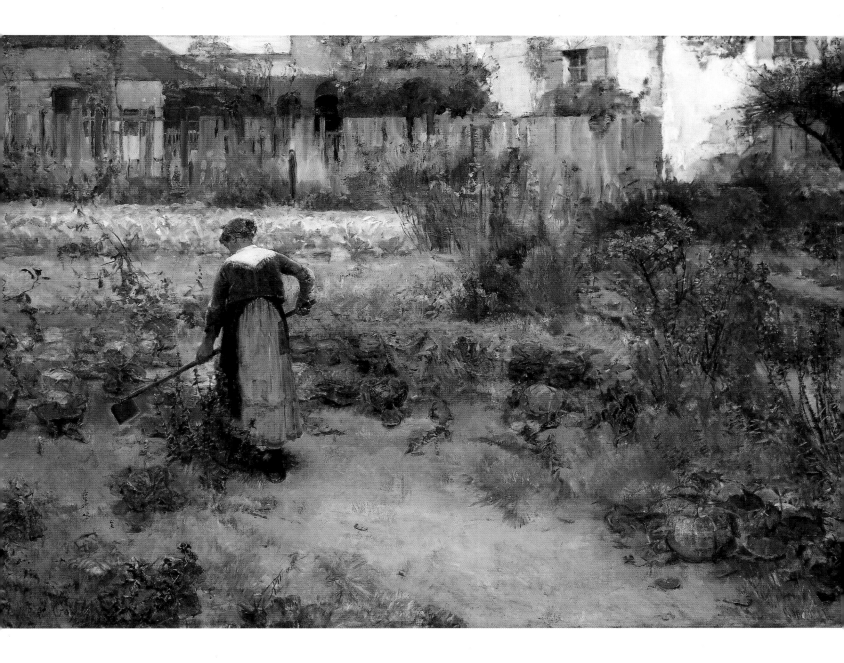

CHILDE HASSAM

1859–1935

Improvisation

1899, oil
76.3 x 86.2 cm
Smithsonian
American Art
Museum, Gift of
John Gellatly

Painted at the Isles of Shoals off New Hampshire, where Hassam passed many summers, *Improvisation* depicts the niece of Hassam's friend the poet Celia Thaxter, playing the piano. Seated by a window, her head is haloed against lush nature, which spills inside and blends with the room's curtains. Single blossoms in elongated vases are scattered across the piano top and the polished table in the foreground, their arrangement resembling notes on a musical score. Hassam's impressionistic brush strokes, the pastel hues shot through with touches of white, embody a rhythm of their own, making the entire image a visual as well as a musical improvisation.

Many nineteenth-century artists were intrigued by the relationship between painting and music and sought to give visual form to sound. By harmonizing the pastel palette with the horizontal and vertical elements such as the piano top and the picture frame on the wall, Hassam alludes to music's underlying structure, while his bravura paint handling evokes the freedom of improvisation. When exhibited in Chicago around 1900, a critic described it simply as "marvelously beautiful."

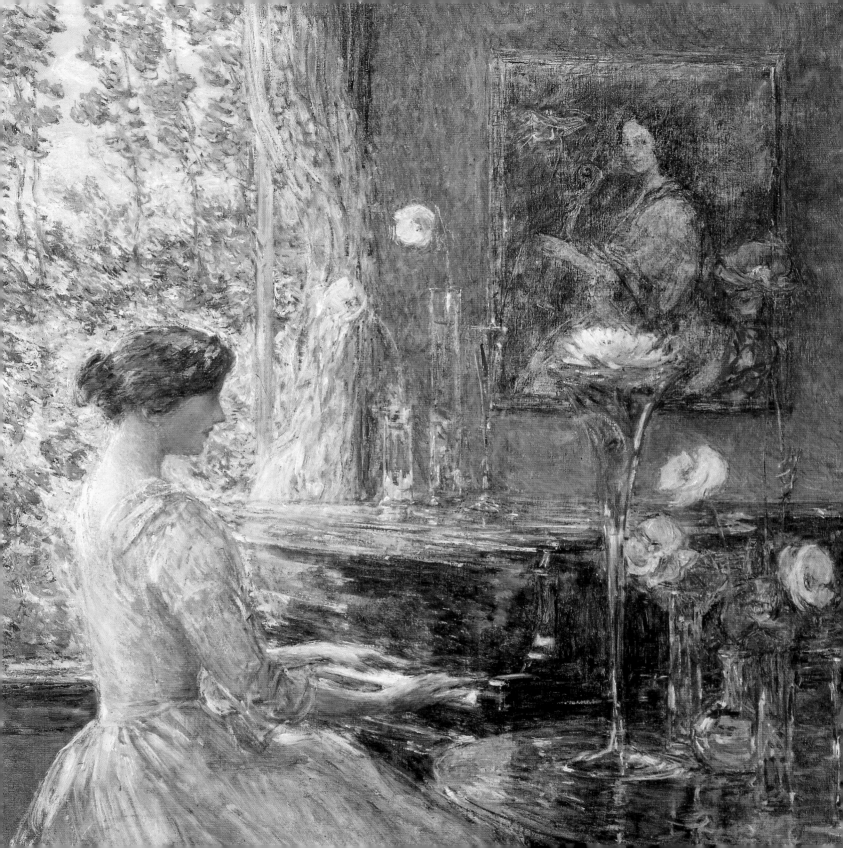

ALBERT HERTER

1871–1950

Woman with Red Hair

1894, oil
81.3 x 54.6 cm
Smithsonian
American Art
Museum

This figure exemplifies the luxury and elegance of the Gilded Age. Herter framed the unidentified model's swanlike neck, taut profile, and abundant mass of hair against a lavishly ornamented background that echoes the rich embroidery of her dress; the gossamer filaments attaching the sleeve to the bodice exhibit a refined sensitivity to the exquisitely handcrafted garments of privilege. The painting's format recalls portraiture of the Italian Renaissance, a common aim of turn-of-the-century American artists, revealing their lofty aspirations.

Not strictly a portrait, the painting represents the spirit of art in all its beauty, complexity, and craftsmanship. Herter, like other artists of the period, also made decorative art objects, designing and executing tapestries at the Herter Looms in America with craftsmen brought over from his beloved France. Design and a sophisticated palette of reds, greens, browns, and salmons define this jewel-like image, its emphasis on surface pattern relating directly to textile weaving. In an industrial age when even an aesthete like Henry Adams perceived the machine as a "moral force," Herter decisively took his stand for art.

Gift of Laura Dreyfus Barney and Natalie Clifford Barney in memory of their mother, Alice Pike Barney

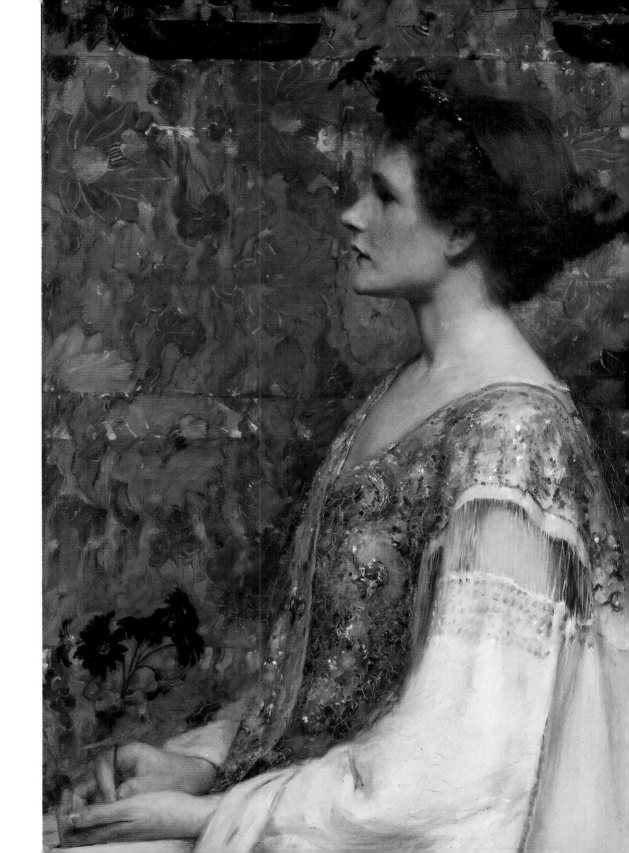

WINSLOW HOMER

1836–1910

High Cliff, Coast of Maine

1894, oil

76.8 x 97.2 cm

Smithsonian
American Art
Museum, Gift of
William T. Evans

In 1894, Winslow Homer was reaching new heights in his work. As he retreated from New York to Maine, the sea replaced the human figure as protagonist in his art. *High Cliff* is one of his boldest compositions.

With forceful, thickly textured brush strokes, Homer delineates the rugged rocks of the promontory, contrasting the earthy reds and browns of the jagged boulders with the gray-green water and white spray of the sea. The artist uses a bold diagonal to stage the eternal warring of the elements, with humankind present only in the diminutive figures atop the cliff at upper right. There, wedged between heaven and earth, they watch, inconsequential before nature.

Despite Homer's own assertion that "I cannot do better than that," the picture did not sell for almost a decade. Yet this may not be so surprising. In its rejection of the picturesque, his work countered the values of the Gilded Age, which, according to many viewers, is how Homer earned his reputation as the greatest American painter of the nineteenth century.

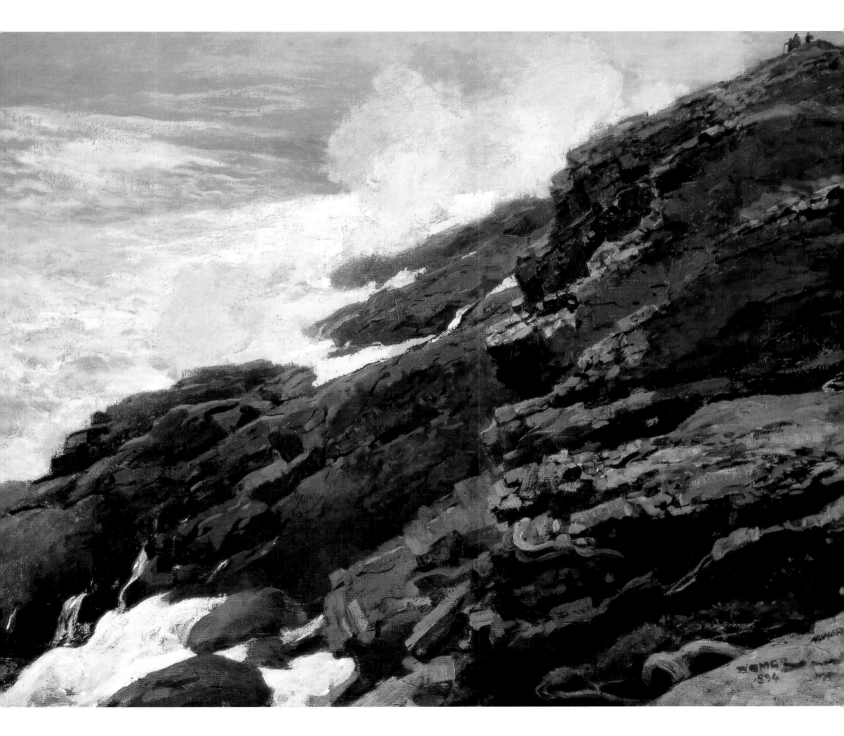

GEORGE INNESS

1825–1894

September Afternoon

1887, oil

95.1 x 73.6 cm

Smithsonian
American Art
Museum, Gift of
William T. Evans

Inness's impressionistic landscape quivers with the ripe fecundity of a summer's day. Our eye moves from the pool in the foreground, where the painter scratched in grasses with the wooden end of his brush, to the multicolored flowers. Farther back, sunlight drenches a patch of grass as two figures at center right move toward the grand trees. A golden glow saturates the landscape, lending a gentle mood that contains only a hint of the autumn to come.

Inness valued color above all; for him it was the soul of painting. Here the vivid blue of the sky, touches of red, and lush green trees reveal nature in all its glory. Yet for Inness this work, like all the landscapes that date from the last decade of his career, was no mere rendering of the observed. Possessing a strong spiritual temperament, and influenced by the eighteenth-century Swedish theologian Emmanuel Swedenborg, the artist sought to capture the atmosphere and poetry, the essence, of the world around him. The painting's chromatic intensity reveals Inness's conviction that color communicates certain spiritual connotations, pointing to the world beyond. In its harmony of form and tone, *September Afternoon* articulates a vision far removed from the materialistic concerns of the Gilded Age.

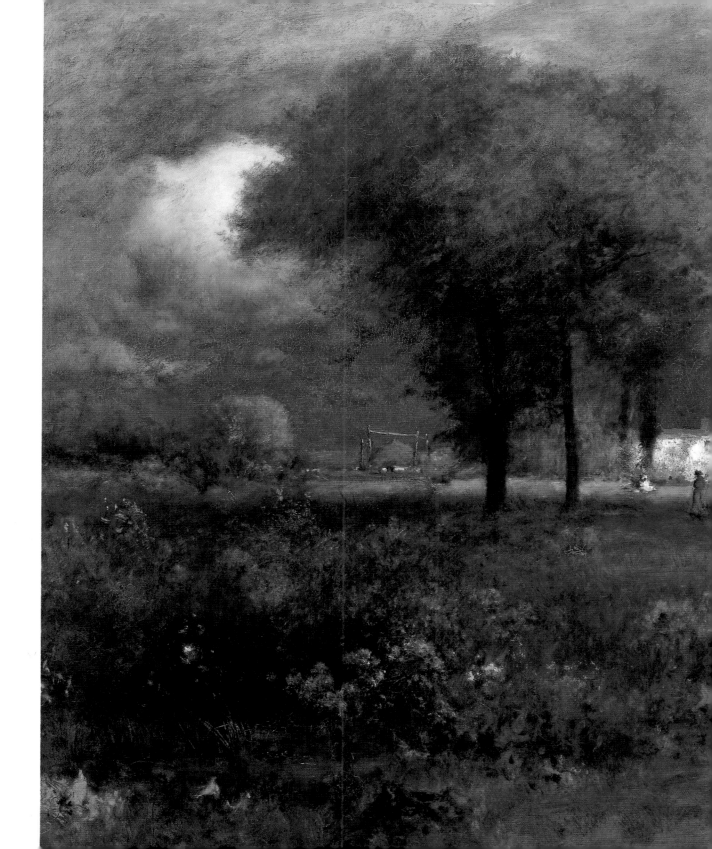

CHAUNCEY BRADLEY IVES

1810–1894

Undine

modeled about 1880
carved 1884, marble
197.2 x 49.2 x 58.4 cm
Smithsonian
American Art
Museum

Naturalistic in spirit yet classical in form, *Undine* responded to the desire of Gilded Age patrons for beautiful figures dignified by allusions to literary, biblical, or mythological sources. The life-size sculpture, with its rendering of wet, clinging drapery, is a tour de force of carving. The gown cascades down the back of the work in rippling, wavy folds, recalling the waters from which Undine emerged.

Undine is the principal character in Friedrich von Fouqué's 1811 novel of the same name. The book, which appeared in America in 1823, recounts the tale of how a water nymph, wishing to leave the sea and receive an immortal soul, assumes human form in order to marry a mortal. For his sculpture, Ives chose the dramatic moment when the nymph rises from the waters to seek revenge on her unfaithful husband; she is a tragic victim of fate and a figure of moral retribution. The story was popularized in opera as well as painting and sculpture; four other Americans besides Ives made images of Undine. But his version, with its compelling combination of physical beauty and spiritual effect, remains the best known and most loved.

Museum purchase made possible in part by the Luisita L. and Franz H. Denghausen Endowment

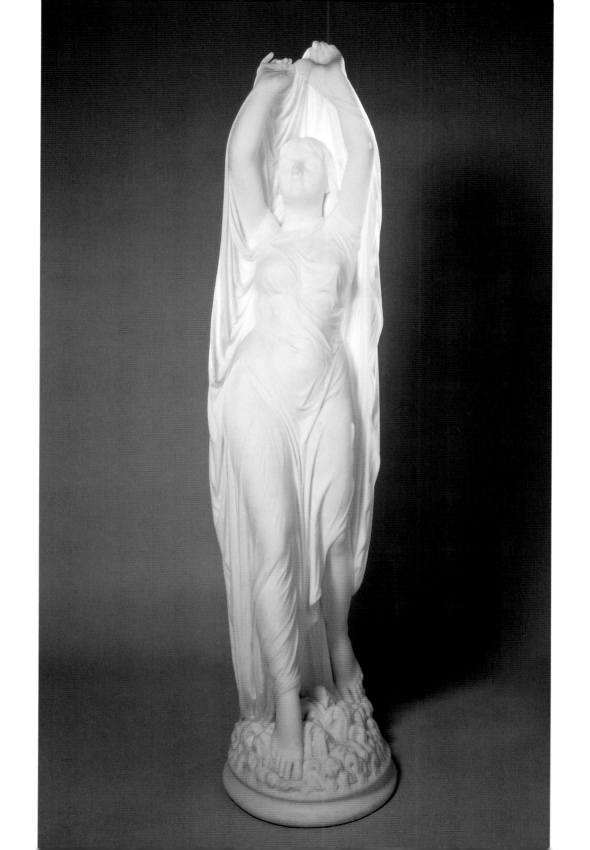

EASTMAN JOHNSON

1824–1906

The Girl I Left Behind Me

1870–75, oil
106.7 x 88.7 cm
Smithsonian
American Art
Museum

On a hill overlooking a vast expanse of land, a young woman stands silhouetted against a stormy sky, her reddish blond locks and cloak caught in the wind. Clutching books with a hand that displays a wedding ring, deep in thought, the girl steps unaware on her shawl. So intense is the emotion of this painting, with nature mirroring the figure's inner turmoil, that it transcends a mere genre subject for an image of true psychological and emotional complexity.

Johnson himself never explained what his picture intended to signify, but the title refers to an Irish ballad popular in the Civil War. Is the girl waiting for her husband to return from battle? In her pose, unruly hair, and profile, this image of heroic American womanhood conveys strength, determination, courage, and sensuality. Little more is known of this work. Johnson here departed from his usual narrative scenes, leaving us with a mystery.

Museum purchase made possible in part by Mrs. Alexander Hamilton Rice in memory of her husband and by Ralph Cross Johnson

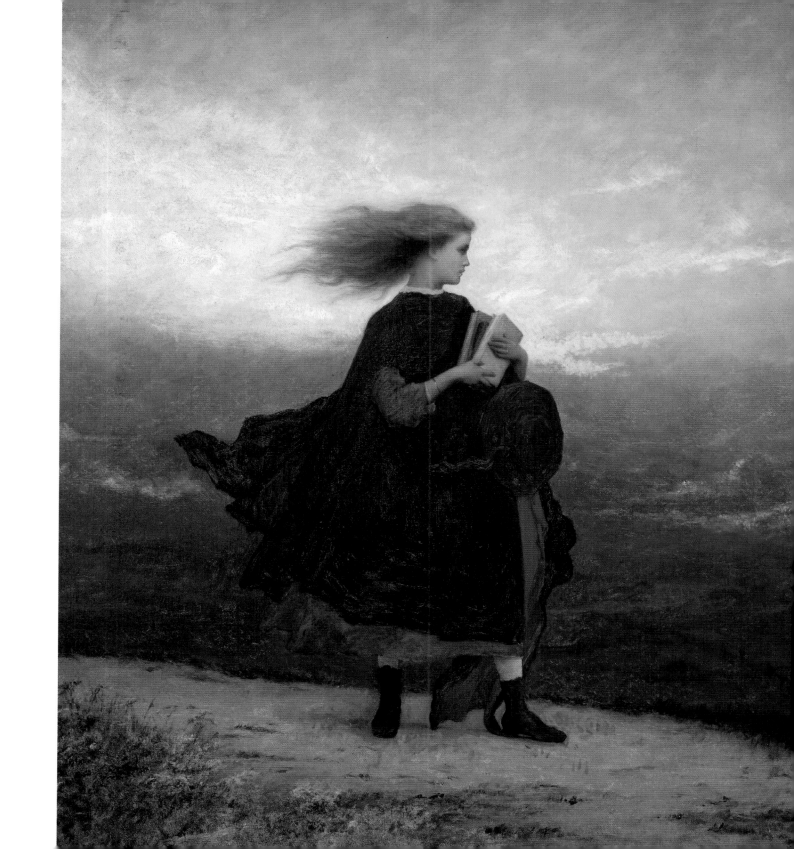

HUGH BOLTON JONES

1848–1927

Lighthouse Beach, Annisquam

about 1887, oil
61.6 x 102.6 cm
Smithsonian
American Art
Museum

Jones may have worked on this picture while visiting the painter William Lamb Picknell, who had settled in Annisquam in the early 1880s after returning from study in France. Indeed, in 1887, Picknell painted a view of the same site but from a different direction. One can imagine the two artists working under the sun and the billowy clouds, their goal to seize both the sun-washed details of sand, rock, and dune, and the tang of the salt air.

Jones welcomes us into the New England setting with a wide view of the sandy road. Our gaze zigzags past the long poles that guide us to where a lone figure makes his way to the water. Even in the increasingly noisy and industrialized world, the painter suggests, one can still find places of repose and delight.

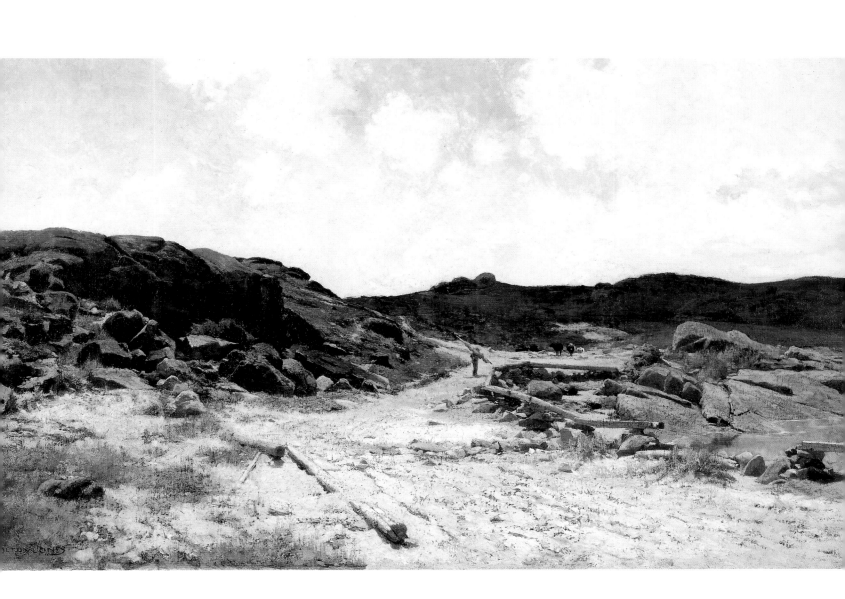

WILLIAM SERGEANT KENDALL

1869–1938

An Interlude

1907, oil

112 x 109.8 cm

Smithsonian

American Art

Museum, Gift of

William T. Evans

By 1910, Kendall had become America's best-known painter of children. Although he received commissions for portraits from such well-to-do sitters as President Taft and Mrs. Vincent Astor, it was his wife, Margaret, and their three daughters who remained his favorite subjects and inspiration for many decades. *An Interlude* shows his wife kissing their five-year-old daughter Beatrice, as they pause from reading a children's book.

Kendall, who succeeded John Ferguson Weir as head of the fine arts department at Yale University, rejected the modernist styles that were beginning to hold sway in sophisticated art circles and retained his technique of evenly lit realism. But this image of motherly love seems compromised. The darkness of the covered window at left meets the lightness of the wall at right in a stark line that bisects the picture and separates the figures physically and emotionally. Beatrice gazes at us with solemn, sorrowful eyes; and we stare into the heart of a child, uncertain about the future beyond the mother's protective reach.

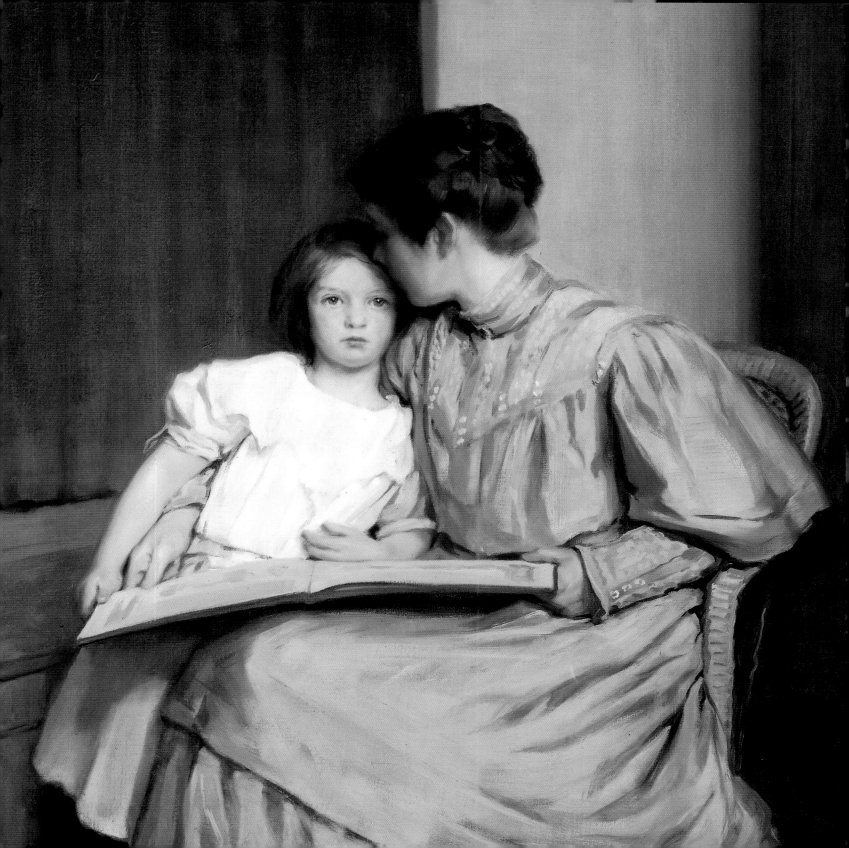

JOHN LA FARGE

1835–1910

Wreath of Flowers

1866, oil
61.1 x 33.1 cm
Smithsonian
American Art
Museum, Gift of
John Gellatly

Critic James Jackson Jarves observed of La Farge's paintings that, "However beautiful [they] may seem to the eye, La Farge makes his subjects present a still more subtle beauty to the mind, which finds in it a relationship of spirit as well as matter." Indeed, this stark image of a wreath on an ancient stucco wall conveys a symbolic message, though scholars have debated its meaning. According to one interpretation, the wreath is a love offering hung on a beloved's wall by a hopeful suitor—an ancient Greek custom. Another critic discerns a funerary quality, a musing on the fragility of life. The Greek inscription, scratched like a graffito into the scumbled plaster wall, reads, "As summer was just beginning," a phrase with hopeful connotations. Rich in subtle red, pink, and green hues, this intimate picture transcends still life for a higher meaning.

Interweaving classical history and culture, *Wreath of Flowers* reflects La Farge's deeply cultivated intellect. Painter, stained-glass designer, interior decorator, friend to Henry James, Augustus Saint-Gaudens, and Winslow Homer, this artist of French Catholic heritage was also an important influence on his contemporaries.

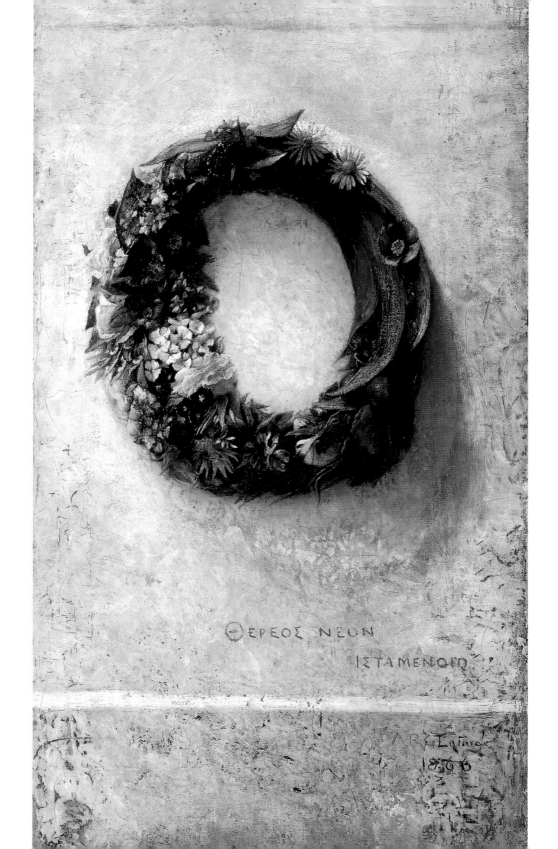

ΘΕΡΕΟΣ ΝΕΟΝ

ΙΣΤΑΜΕΝΟΙΟ

WILLIAM HENRY LIPPINCOTT

1849–1920

Farm Interior: Breton Children Feeding Rabbits

1878, oil

54.6 x 65.4 cm

Smithsonian

American Art

Museum

The charm of this Breton genre scene reminds us how important a role European study and subject matter played in American art throughout the nineteenth century. In 1875, Lippincott departed Philadelphia for France. After acquiring a solid technique from the Salon painter Léon Bonnat in Paris, he joined a colony of American painters in Pont-Aven in Brittany, where he observed the Breton people, considered picturesque by their own compatriots as well as by Americans.

Working from life studies, he proceeded to assemble finished compositions such as *Farm Interior.* The painter posed the three peasant children against a massive fireplace that adorned the Château de Lezaven, site of the painting studio shared by generations of American artists abroad. Interested in the narrative details that sparked life into the old-world setting, Lippincott rendered the household knick-knacks with the same care he lavished on the farmyard animals. A glowing light caresses this vision of sweet, uncomplicated childhood.

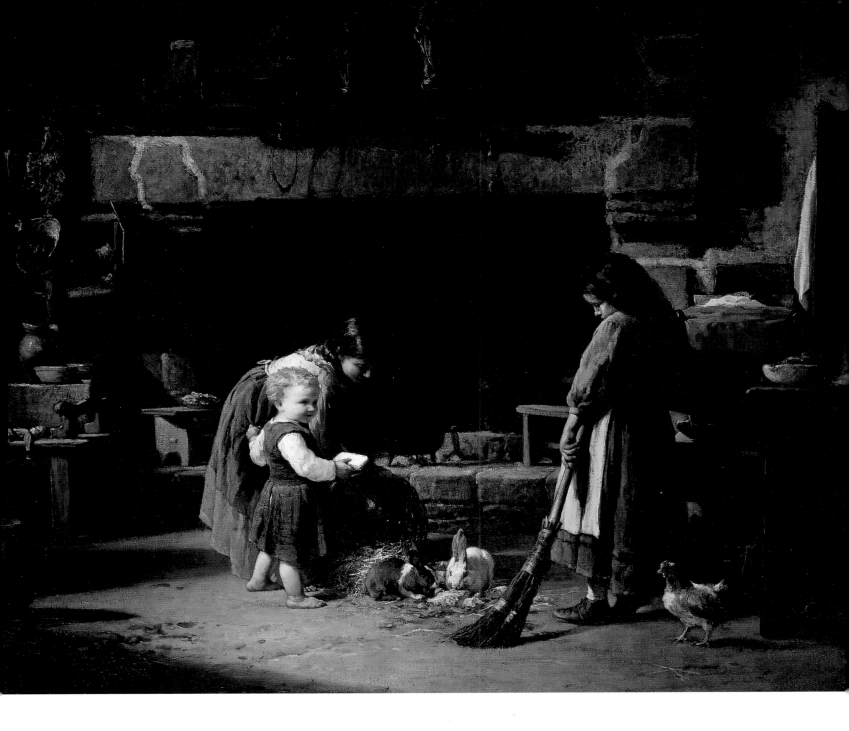

FREDERICK MacMONNIES

1863–1937

Venus and Adonis

1895, bronze
71.8 x 49.8 x 25.4 cm
Smithsonian
American Art
Museum
Museum purchase
made possible in part
by the Luisita L. and
Franz H. Denghausen
Endowment

Venus and Adonis cloaks its provocative nudity in mythological guise; here a saucy Venus, goddess of love, flirts with Adonis, who, enamored of hunting, would later be tragically killed by a wild boar. The handsome Adonis holds his mastiff, symbol of the hunt, as the beautiful divinity casually rests her arm on the shoulder of the young man.

MacMonnies specialized in Beaux-Arts sculpture, a creative adaptation of classical styles that lent an elevated tone to art without depriving it of titillating possibilities. In France, where the sculptor spent much of his career, the unabashed nudity of his subjects did not shock; in the United States, however, the work caused a scandal when it appeared in its life-size marble version. At one point it had to be shrouded in burlap so as not to offend American audiences. This bronze version is very rare. Originally modeled in clay, the work was reduced in size for a luxurious private home. Its shiny reddish bronze patina reflects light in a lively manner that complements the frank sensuality of the elegant forms.

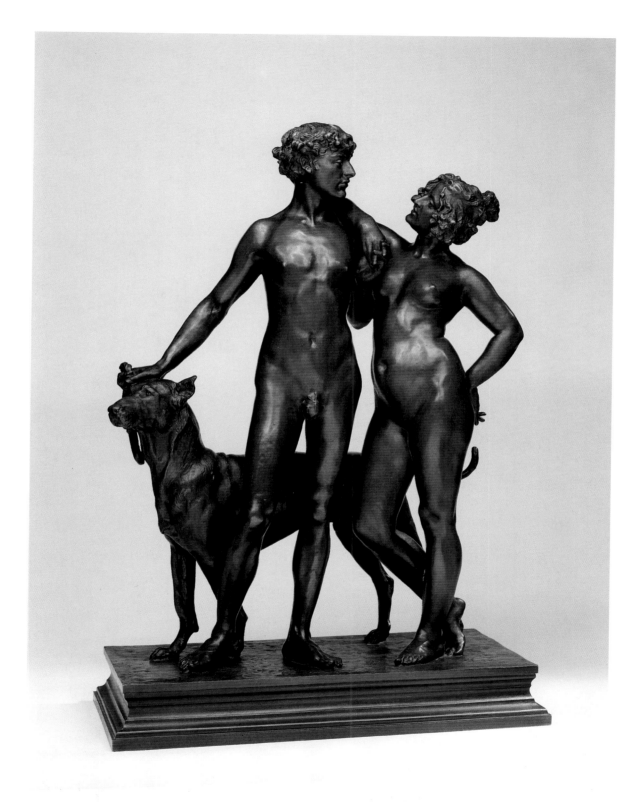

ARTHUR F. MATHEWS

1860–1945

Spring Dance

about 1917, oil
131.7 x 121 cm
Smithsonian
American Art
Museum, Gift of
Mr. and Mrs.
David J. Carlson

In their flowered robes, a group of dancers watches as one of their company demonstrates a new step, strewing blossoms from her outstretched arm. Numerous artists, including Mathews, were influenced by dance at this time. After the hothouse atmosphere of the 1880s and 1890s, when languid, neurasthenic women represented the height of beauty and appeal, health and vigorous movement for ladies became fashionable throughout the Western world.

After studying in Paris in the 1880s, Mathews moved to San Francisco, where he and his wife helped establish the California Arts and Crafts movement. *Spring Dance* not only celebrates the joy in health and exercise that we associate with California even today, but also reveals Mathews's interest in flattening forms into decorative patterns that create a kind of jigsaw-puzzle effect. The ornamental rhythm of clouds, trees, grass, and dancers, painted with soft pastel tones, creates a lively movement of our eyes that in itself is a visual dance.

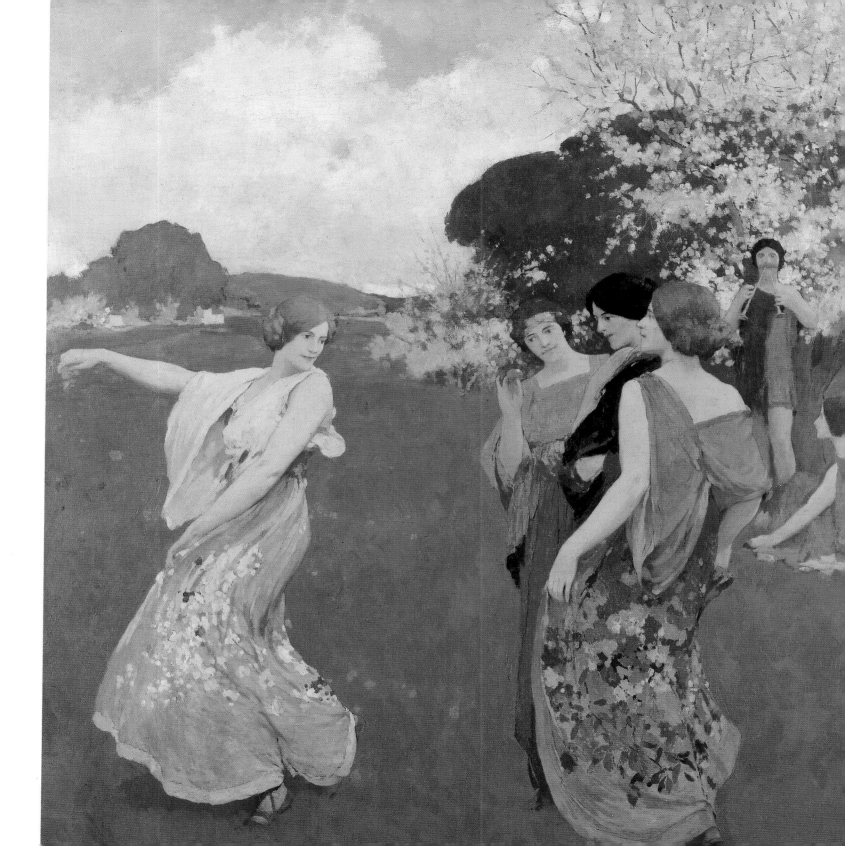

GARI MELCHERS

1860–1932

The Sermon

1886, oil
159 x 219.7 cm
Smithsonian
American Art
Museum, Bequest of
Henry Ward Ranger
through the National
Academy of Design

In this intriguing scene, the congregation of a Dutch church reacts variously to the sermon being preached by an unseen pastor. In a pew against the wall two men listen intently, while the parishioners below them appear far less engaged. One bows her head in pious slumber as her neighbor gazes at her reproachfully.

Melchers delighted in carefully rendered poses in order to present a vivid slice of ordinary life, both psychological and material. The expatriate artist's effective design juxtaposes diagonal rows of simple wooden red chairs with horizontal turquoise pews at rear. Critics frequently alluded to his skill, calling this picture "the last word of realism in painting." Shown in many international exhibitions, *The Sermon* won a gold medal in Munich and became one of the era's best-known American paintings.

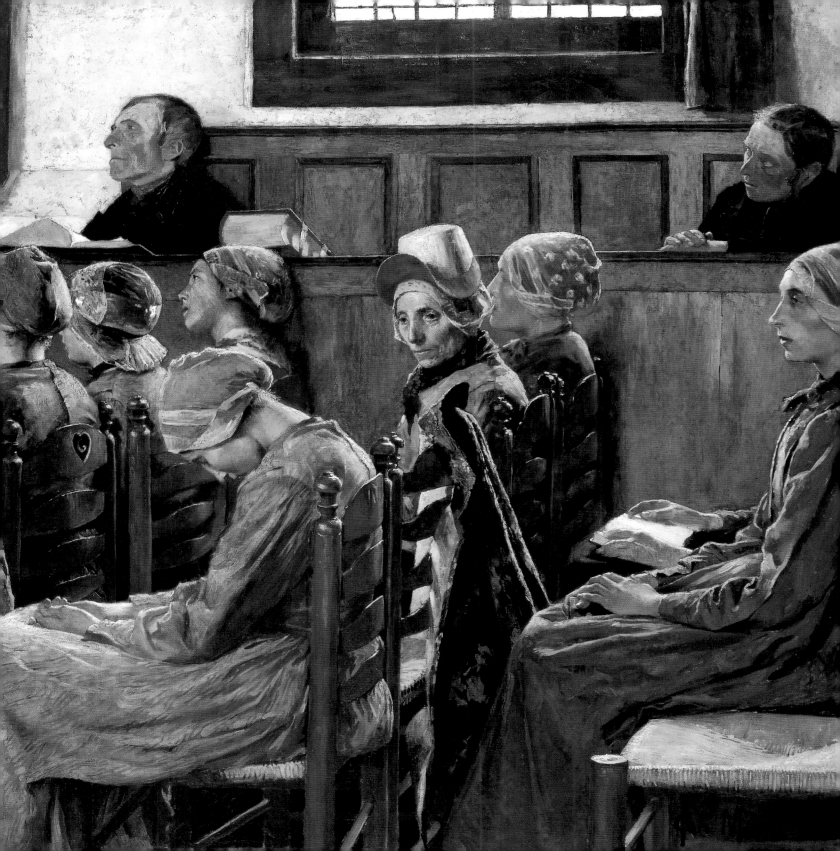

H. SIDDONS MOWBRAY

1858–1928

Idle Hours

1895, oil
30.4 x 40.6 cm
Smithsonian
American Art
Museum, Gift of
William T. Evans

Mowbray used every brilliant color in his palette to satisfy his wealthy Western patrons, and fantasies of the East permeate *Idle Hours*. Here, the artist re-creates a rich interior setting, perhaps a harem, with its cushions, flowers, and mosaic tile floor. Two ladies, lounging in richly colored robes, interrupt their mandolin playing and conversing to gaze at two turtles scuttling away at lower right. Mowbray heightens the sense of confinement by enclosing the women in a compressed space created by sofa, pillows, and the table.

Mowbray achieved fame as both a mural painter and coordinator of fancy interiors, yet was ultimately concerned with creating elegant designs rather than serious easel paintings. Encapsulating Gilded Age luxuriance, *Idle Hours* caught the attention of collector William T. Evans, who acknowledged that "it is a remarkable performance technically."

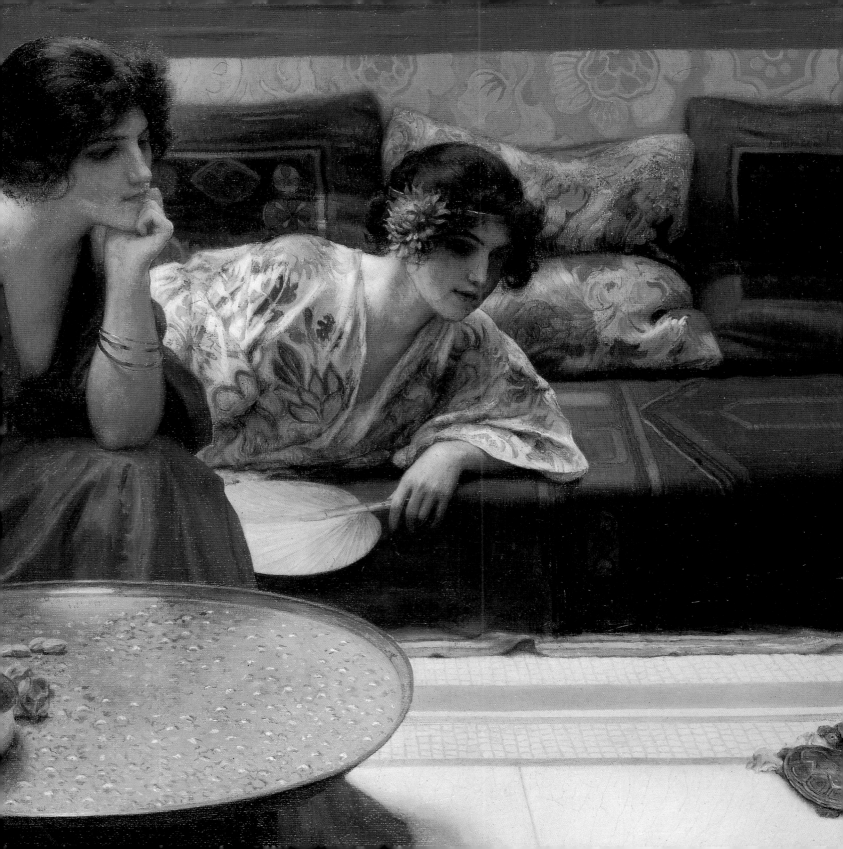

ELIZABETH NOURSE

1859–1938

Fisher Girl of Picardy

1889, oil

118.7 x 82 cm

Smithsonian

American Art

Museum, Gift of

Elizabeth Pilling

This coarse-featured peasant girl stands with her little brother atop a sand-blown dune. A creature of her environment, she wears a sand-colored skirt, against which her reddened face, arms, and hand betray her hardy, outdoor existence. The boy's colorful brown trousers and red shirt stand out like a beacon on this gray day. The pose, however, is heroic. Seen from below, silhouetted against the sky and balanced by the strong slant of the poles and nets, the fisher girl is a noble figure, strong, protective, independent. The bold verticals and diagonals reinforce the sense of grandeur bestowed upon the sister and brother by the sympathy and respect of the painter.

An expatriate who spent most of her life in France, Nourse was intensely religious; she cared deeply about her models, helping them and their families in any way she could. Such clear-eyed charity emerges in this work, with its honesty, monumentality, and insight.

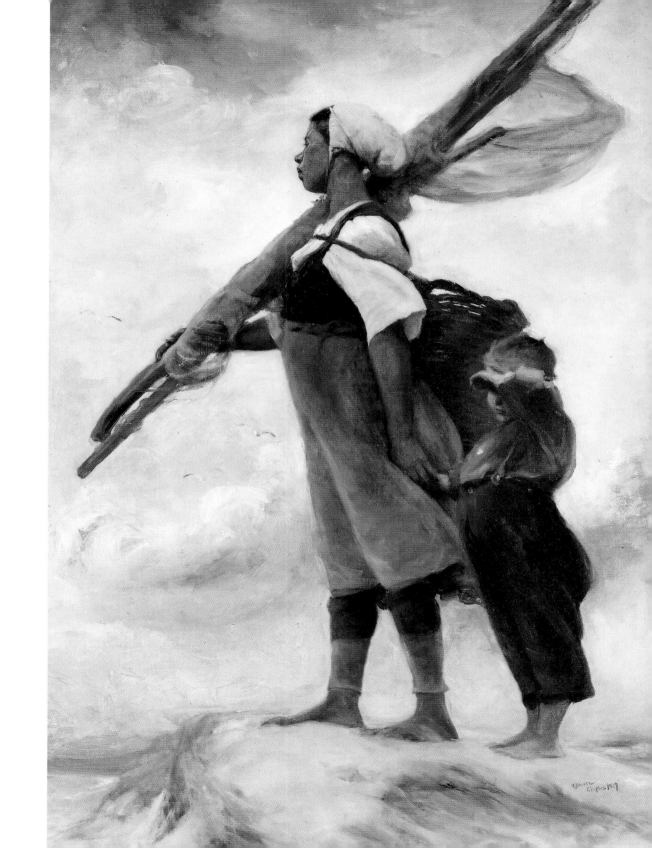

WILLIAM ORDWAY PARTRIDGE

1861–1930

Alfred, Lord Tennyson

modeled by 1899
bronze
50.8 x 33 x 20.3 cm
Smithsonian
American Art
Museum, Gift of
Mrs. William
Ordway Partridge

This bronze head of the poet Alfred, Lord Tennyson is one of many commissions Partridge received to portray contemporary as well as historical personages. Tennyson had died only seven years earlier and still loomed large in the consciousness of the period. His long locks, high, noble forehead, and abundant beard provided promising material for the sculptor, who may have modeled Tennyson from life. The set of the sitter's mouth, the fine aquiline nose, and the slightly downcast eyes convey the thoughtfulness of the philosopher as well as the determination of the advocate of social reform.

Modeling in an impressionistic manner, Partridge excavated deep spaces in the hair and beard, allowing light to play across their irregular surfaces. By contrast, he emphasized the smoothness of the bridge of the nose and the forehead, which reflects light as if referring to the spark of inspiration within Tennyson's mind. Meditative yet spontaneous and alive with feeling, Partridge's sculpture expresses the quiet force of a poet who symbolized an era.

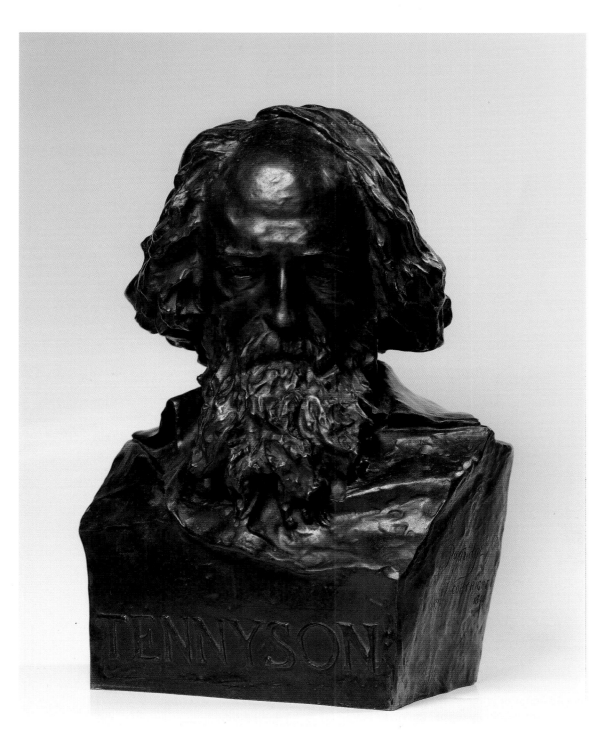

CHARLES SPRAGUE PEARCE

1851–1914

Lamentations over the Death of the Firstborn of Egypt

1877, oil
97.8 x 130.8 cm
Smithsonian
American Art
Museum

Based on a passage from the Book of Exodus, this image shows a couple mourning the loss of their firstborn son, slaughtered by a vengeful pharaoh. Posed against a wall decorated with hieroglyphics and other Egyptian motifs, the weeping parents shield their faces as they watch over the child's sarcophagus. At lower right, a group of funerary figures lying shattered on the stone floor refers to the tragic deaths in the land.

The image contains a pastiche of objects, which set the stage for this Old Testament scene. However, art historians believe that the hieroglyphics and objects are largely fanciful, although Pearce, an expatriate who spent most of his life in Paris, did travel to Egypt. He accompanied Frederick A. Bridgman there in 1873, bringing back numerous artifacts from which to work. But historical accuracy was less important than the powerful effect that this picture worked on viewers. Juries selected it for exhibition in prestigious shows, where it won Pearce renown and elicited mixed reviews from critics. Tightly composed and emotionally charged, the painting responded to the desire of Gilded Age patrons for exotic locales as well as for reminders of a more spiritual existence.

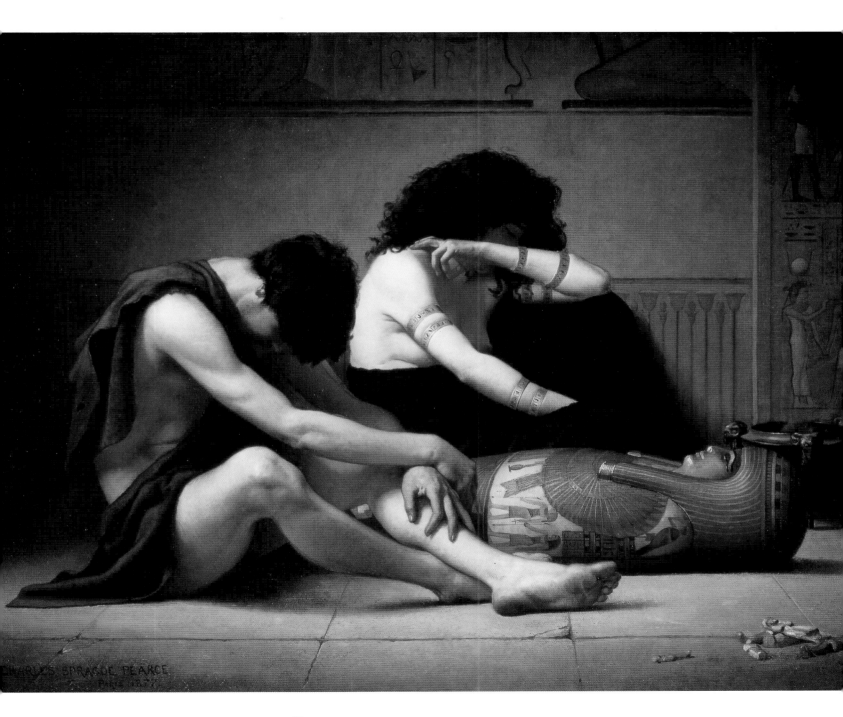

ALBERT PINKHAM RYDER

1847–1917

Jonah

about 1885–95, oil
69.2 x 87.3 cm
Smithsonian
American Art
Museum, Gift of
John Gellatly

Ryder's images betray his obsession with stories of the sea. "I am in ecstasy over my Jonah . . . ," wrote Ryder to a collector, ". . . such a lovely turmoil of boiling water and everything." Amid the stormy turmoil, the whale swoops in at the right to swallow the prophet, whose mouth opens wide in horror. Terrified sailors huddle in their small boat, overwhelmed by the forces of God and nature.

The painter laid thick layers of pigment on the canvas, literally encrusting the image onto the surface and heightening the sense of urgency. The visage of God looms above the stormy sea, rising from a pattern of cloud-wings. After abandoning simple landscape scenes, Ryder chose visionary subjects from sources as varied as the Bible and classical mythology, transforming them through the alembic of his tortured imagination. One of the great visionaries among American painters, Ryder ignored the glitter of the Gilded Age, looking inward instead in order to reveal the dark mysteries of God, nature, and the human soul.

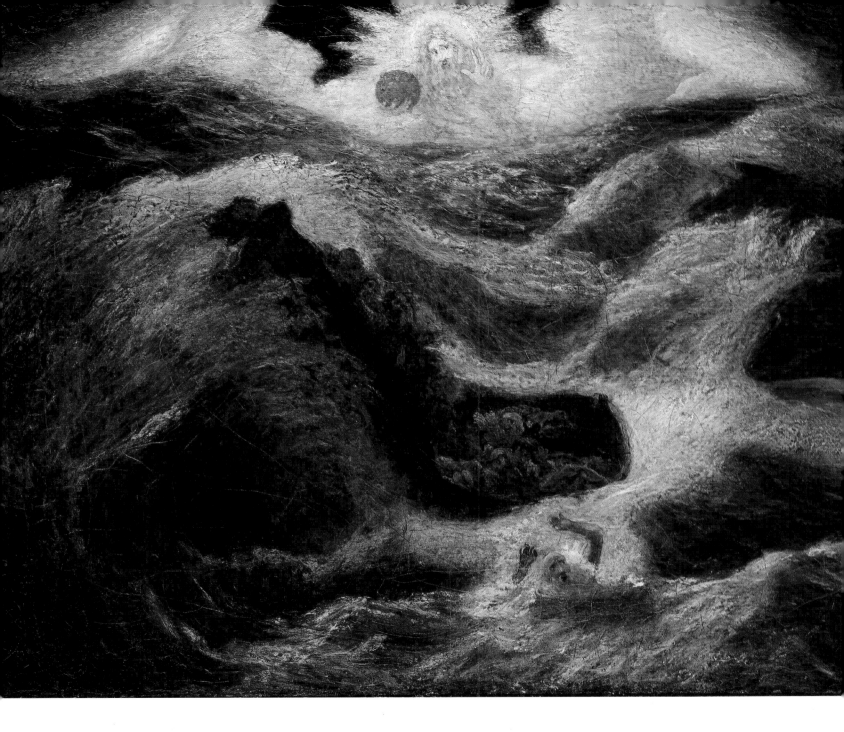

ALBERT PINKHAM RYDER

1847–1917

Lord Ullin's Daughter

before 1907, oil
52 x 46.7 cm
Smithsonian
American Art
Museum, Gift of
John Gellatly

Ryder's terrifying vision recounts the Scottish legend of Lord Ullin's daughter. Her small boat trapped amid tumultuous waves, surrounded by steep cliffs and menacing clouds, she and her chieftain lover attempt to flee her wrathful father. Based on the 1809 poem by Thomas Campbell, the picture brings his words to life in the artist's nightmarish vision of the rough channel far in the Scottish north. Together in a fragile craft under dramatically moonlit heavens, the doomed lovers cling to their last moment together before their boat capsizes.

A dark palette emphasizes the imaginative quality of the image; it could not be more removed in subject and handling from an impressionist seascape. In its romantic themes of nature's sublime power and the passion of love and death, Ryder's painting embodies the mystical preoccupations of the end of the century, the spiritual corrective to the extravagant materialism of the Gilded Age.

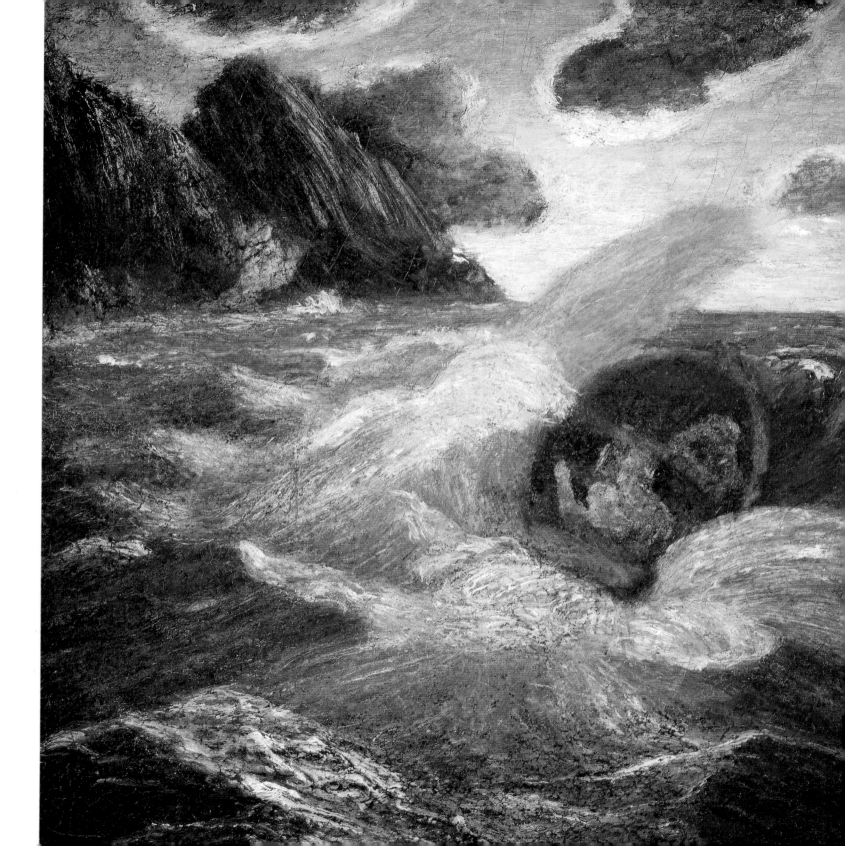

ALBERT PINKHAM RYDER

1847–1917

With Sloping Mast and Dipping Prow

about 1880–85, oil
30.4 x 30.4 cm
Smithsonian
American Art
Museum, Gift of
John Gellatly

"With sloping masts and dipping prow . . ./The ship drove fast, loud roared the blast,/And southward aye we flew." Ryder drew on a literary source for his art, Samuel Taylor Coleridge's "Rime of the Ancient Mariner." In this quintessentially romantic poem, a sailor pays dearly for his gratuitous slaughter of an albatross, learning from the tragedy to cherish all living things. Wandering the seas as penance, he carries his message to everyone who will listen.

Ryder's small ship glides on the open sea under moonlight, a moody meditation on human folly and the quest for redemption. Perched in the prow, the mariner gazes out at sea and heaven, potent reminders of the immensity of nature and the mind of God. Mixing hues of blue, green, and white on the canvas so that flecks of color would be revealed from the numerous paint layers, Ryder created a dense, compacted surface that eloquently complements the complex philosophical ruminations of his enigmatic art.

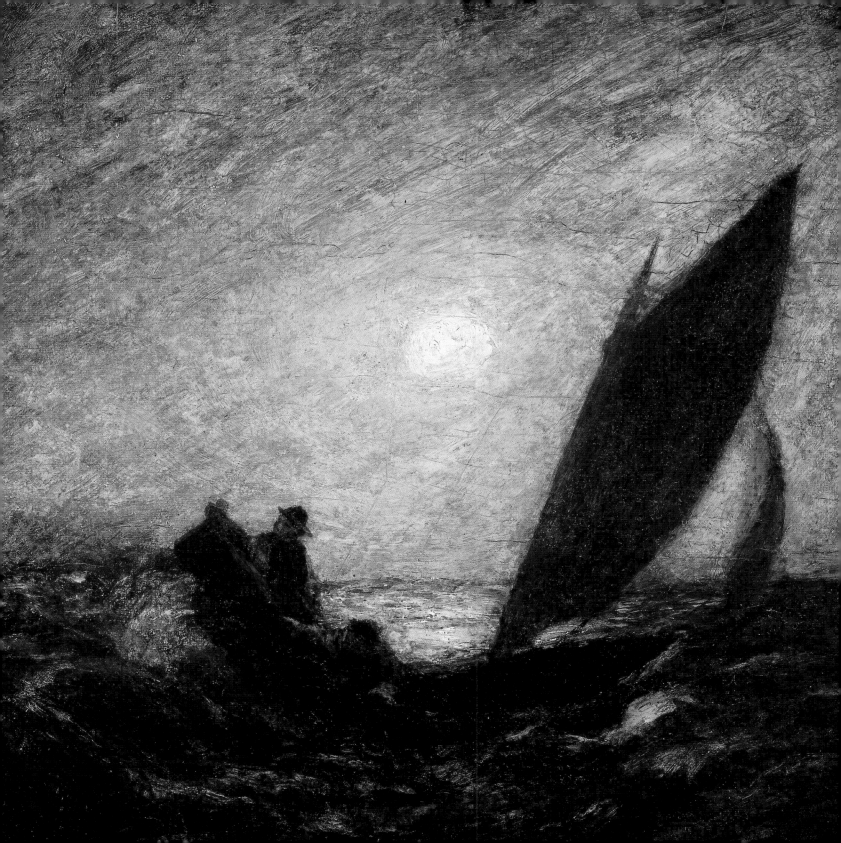

AUGUSTUS SAINT-GAUDENS

1848–1907

The Adams Memorial

modeled 1886–91
cast 1969, bronze
177.4 x 101.4 x 112.9 cm
Smithsonian
American Art
Museum

The Adams Memorial is one of American art's most hauntingly eloquent sculptures. Eyes closed, the shrouded figure remains in repose, lost in meditation. Depending on the light source, all features except nose and mouth lie buried in the shadows cast by the hood. Remote, solitary, positioned against a wall with no name or identifying inscription, the work resists interaction with the viewer, remaining mysterious and ultimately inaccessible.

Writer, Harvard professor, and descendant of presidents, Henry Adams commissioned the statue from Saint-Gaudens to commemorate his wife, "Clover" Adams, who committed suicide in 1885. The sculptor experimented with numerous ideas as he sought to fulfill Adams's wish for a figure that would symbolize "the acceptance, intellectually, of the inevitable." Sometimes referred to as "Grief," the work was described by Adams as embodying "the oldest idea known to human thought." The first cast resides in Rock Creek Church Cemetery in Washington, D.C., over the graves of both Clover and Henry Adams.

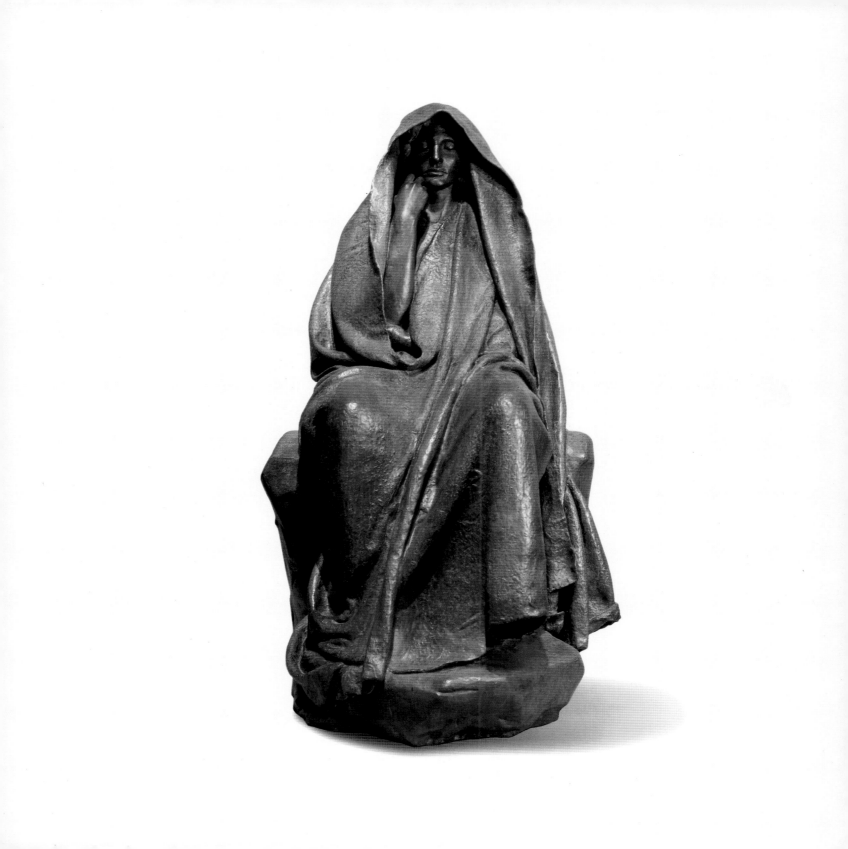

AUGUSTUS SAINT-GAUDENS

1848–1907

Diana

1889, bronze
63.4 x 32 x 34.7 cm
Smithsonian
American Art
Museum, Gift of
John Gellatly

Saint-Gaudens designed the exquisite figure of Diana, goddess of the moon and the hunt, to grace the pinnacle of his architect-friend Stanford White's new Madison Square Garden building in New York City. It proved too large for the skyscraper, even when displayed more than three hundred feet above the street, so the sculpture was removed and placed on the dome of the Agriculture Building at the 1893 World's Columbian Exposition in Chicago. A tragic fire destroyed the work at the end of the fair.

This bronze is a unique cast of the preliminary model made for the original *Diana*, our only sculptural record of Saint-Gaudens's first conception. The bronze still shows the surface texture of the clay model from which it was cast, adding to the visual interest of the idealized form. Perfectly balanced on her orb, crescent moon ornamenting her forehead, the goddess is just about to loose the arrow to its mark. Combining tensile athleticism with formal grace, pure in proportion and line from all visual angles, the sculpture is America's homage to antiquity and its own cultural aspirations at the turn of the century.

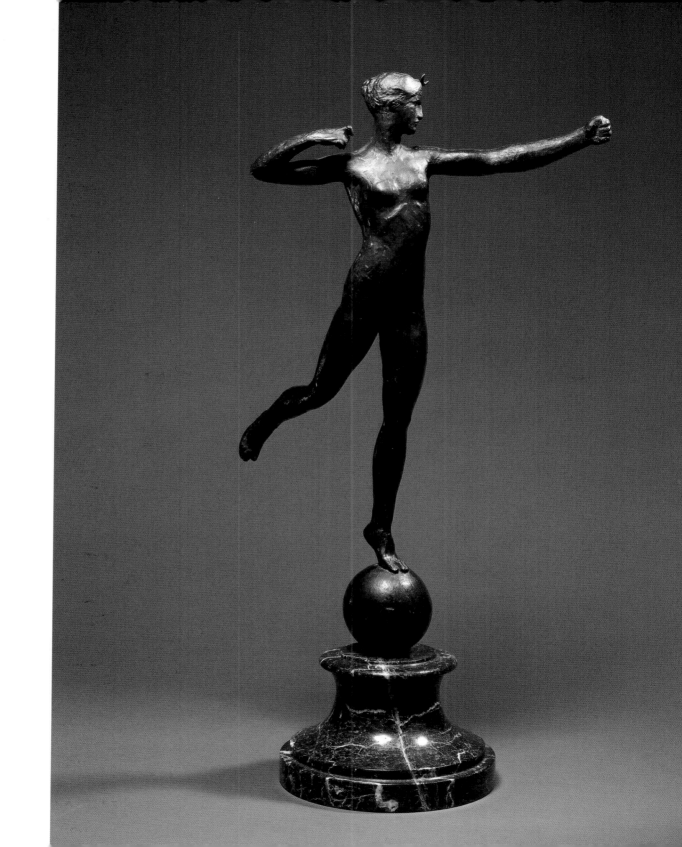

AUGUSTUS SAINT-GAUDENS

1848–1907

Robert Louis Stevenson

modeled 1887
cast 1899, bronze
27.7 x 44.5 x 2.2 cm
Smithsonian
American Art
Museum, Bequest
of Olin Dows

Draped with a blanket and propped up with pillows, the writer sits in bed, a book against his knees and a cigarette in his right hand. The bedposts frame the scene, providing a solid structure for the delicate curves and folds of the bedclothes. Stevenson's fine profile is silhouetted against the background, directly facing the figure of Pegasus, the flying horse from classical mythology.

This beautifully balanced work carries within it all the sculptor's admiration and sympathy for the dying Stevenson. After meeting each other in 1887, Saint-Gaudens asked to sculpt his new friend, sending the finished work to him at his home in Samoa several years later, just before the poet's death from tuberculosis at the age of forty-four. Saint-Gaudens felt transformed by his acquaintance with Stevenson, who was delighted by the portrait relief. The permanence of the bronze image may have comforted the ailing poet, whose lines from "Underwoods" decorate the piece. In the poem he asked and answered the question of any artist: "Where hath the fleeting beauty led/To the doorway of the dead . . ."

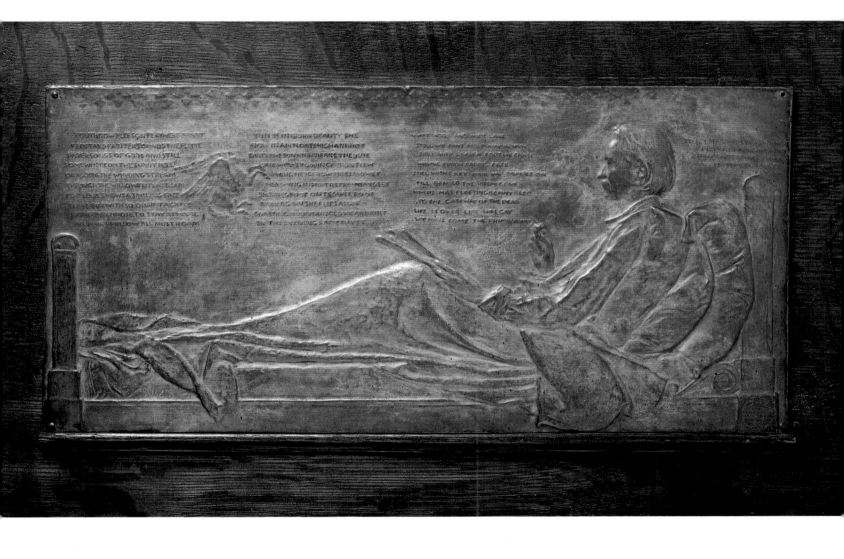

Elizabeth Winthrop Chanler

1893, oil
125.4 x 102.9 cm
Smithsonian
American Art
Museum, Gift of
Chanler A. Chapman

"Bessie" Chanler's determination and strength of character emerge forcefully in Sargent's remarkable portrait. Positioned firmly in the center of the carefully ordered interior, the twenty-six-year-old woman stares at the viewer, jaw set, with a tense expression. Only nine when her mother died, Bessie shouldered responsibility for her seven younger siblings. Wealth and social position did not shield her from further tragedy; after developing a disease of the hip at age thirteen, she lived for two years strapped to a board to prevent curvature of the spine. Yet she traveled extensively, spending time in Asia and Europe, and eventually marrying John Jay Chapman, a family friend.

Bessie's sister Margaret commissioned this portrait during a sojourn in England. Ever the consummate society portraitist, Sargent greatly admired his subject, observing that she possessed "the face of the Madonna and the eyes of the Child." Aware of her difficult life, he framed her in a splendid black satin dress with flamboyant puffed sleeves, a fitting symbol of elegance as well as a poignant reminder of loss.

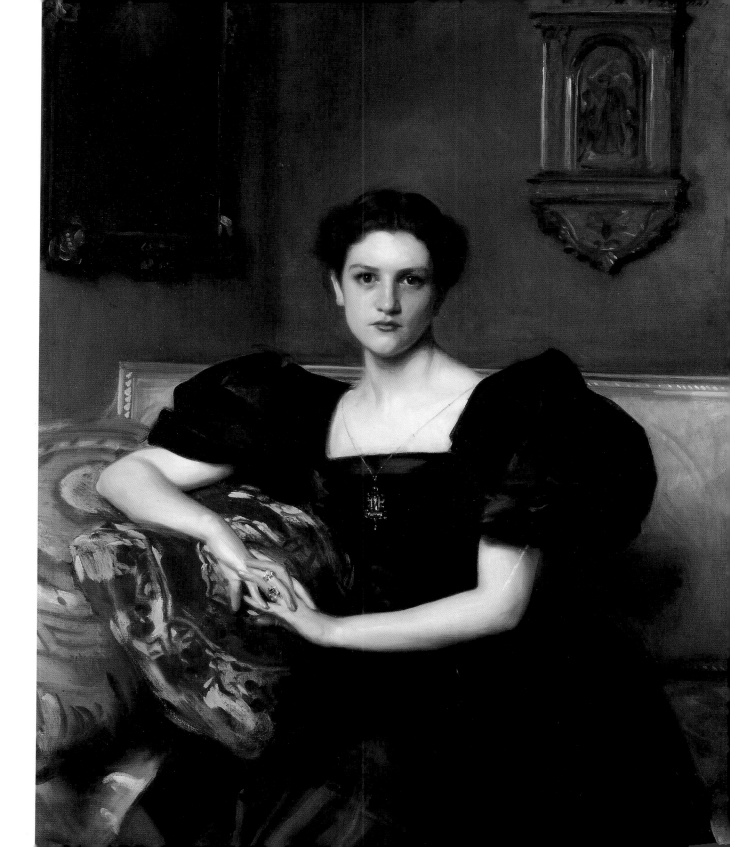

JAMES JEBUSA SHANNON

1862–1923

Mother and Child (Lady Shannon and Kitty)

about 1900–10, oil
117.5 x 98.7 cm
Smithsonian
American Art
Museum, Gift of
John Gellatly

In this elegant interior, the artist's lavishly dressed wife and daughter Kitty enjoy a moment of quiet leisure. Cosmopolitan in feeling, this lushly painted double portrait exhibits a bold composition as Kitty's figure cuts dramatically across the foreground, leading our eyes backward to her mother's exquisite head. A slight awkwardness in the mannered treatment of his wife's hand as it holds her book reveals Shannon's tendency to create flashy effects at the expense of accuracy. Yet this expatriate artist living in Britain enjoyed a stellar reputation and was often compared to another Gilded Age artist, John Singer Sargent.

Supported by the patronage of Queen Victoria, Shannon enjoyed commercial success that brought riches to his family, amply illustrated in this work. After a lucrative career and a fashionable existence spent gambling in Monte Carlo, motoring in his Rolls Royce, and entertaining friends, the painter was knighted in 1922, the year before his death. Though on the other side of the Atlantic, Shannon's life fully accorded with the glamour of America's Gilded Age.

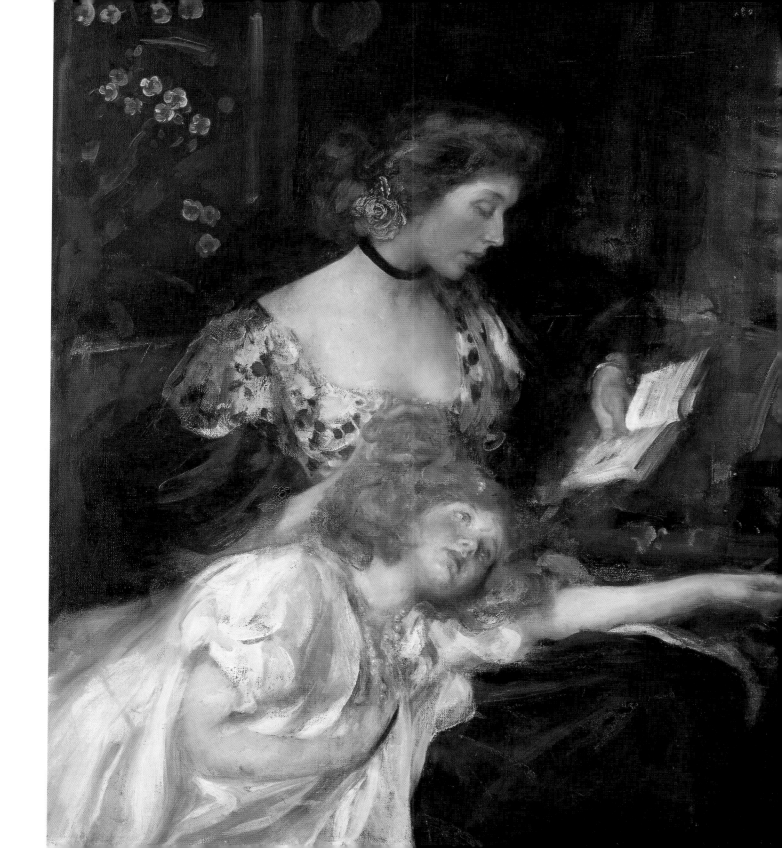

CHARLES WALTER STETSON

1858–1911

Magnolia

1895, oil
61.5 x 51.2 cm
Smithsonian
American Art
Museum

Stetson painted the strange magic of flowers. Springing forth like an apparition, positioned against an indeterminate background, the pale magnolia opens toward us. According to the conventional symbolism of Victorian flower painting, the magnolia represented magnificence. Indeed, the blossom's scale and presence confirm its status among flowers. Some of the magnolia's mysterious power may be attributed to the artist's passionate, tormented nature. Torn between a religious sensibility and a profound sensuality, Stetson's unresolved anxieties seem to merge here and in his images of nudes, monks, and looming trees. Even the California sunshine of his Pasadena home failed to allay his chronic illnesses, and he moved restlessly between the West Coast, Rhode Island, Boston, and Rome. This oddly insistent flower painting was a gift to a lady, inscribed as such on the back of the canvas.

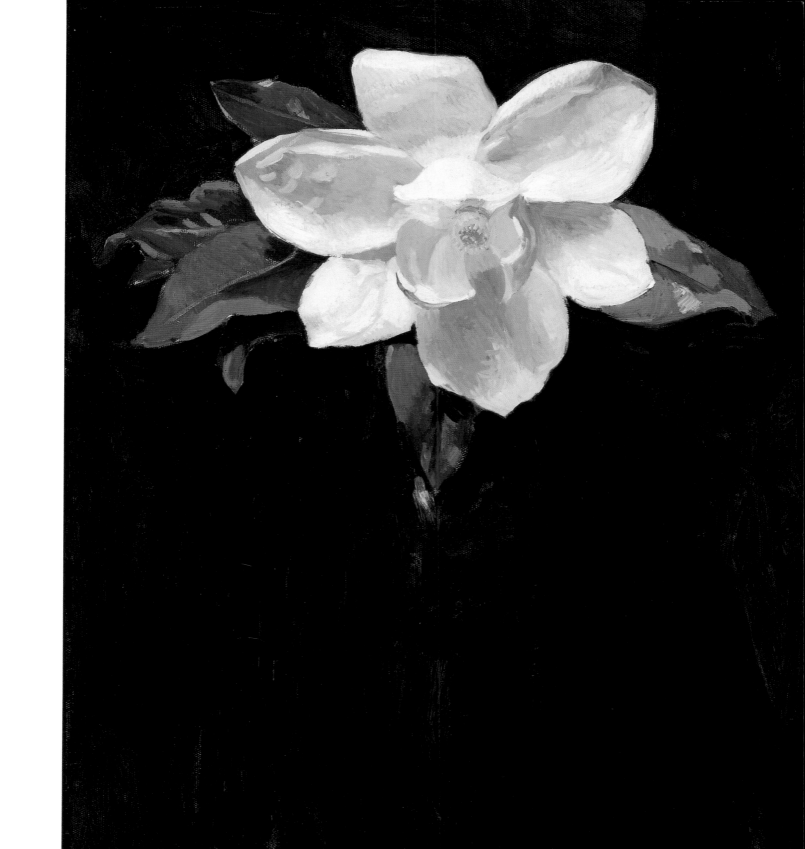

HENRY OSSAWA TANNER

1859–1937

Mary

about 1914, oil
115.5 x 88.2 cm
Smithsonian
American Art
Museum, Gift of
Mrs. Dorothy L. McGuire

Alone in her chamber, poised among looming shadows, a young girl senses the arrival of the angel who will announce that she will bear the Son of God. Atmospheric blue and violet hues intensify this mysterious, sacred moment; golden candlelight suggests spiritual illumination. With uncanny insight, Tanner captures both fragile humanity and revelation's radiant glow.

Described in 1914 as the "poet-painter of Palestine," Tanner depicted the Mother of God numerous times. To his deeply religious mind, Mary symbolized faith and fortitude. These qualities were especially significant in 1914, when war threatened France, to which Tanner had immigrated in order to escape antiblack sentiment in the United States. Although few artists portrayed biblical subjects in the world reshaped by Darwin and Freud, Tanner's profound faith inspired him to paint the divine spirit at work in the lives of simple people.

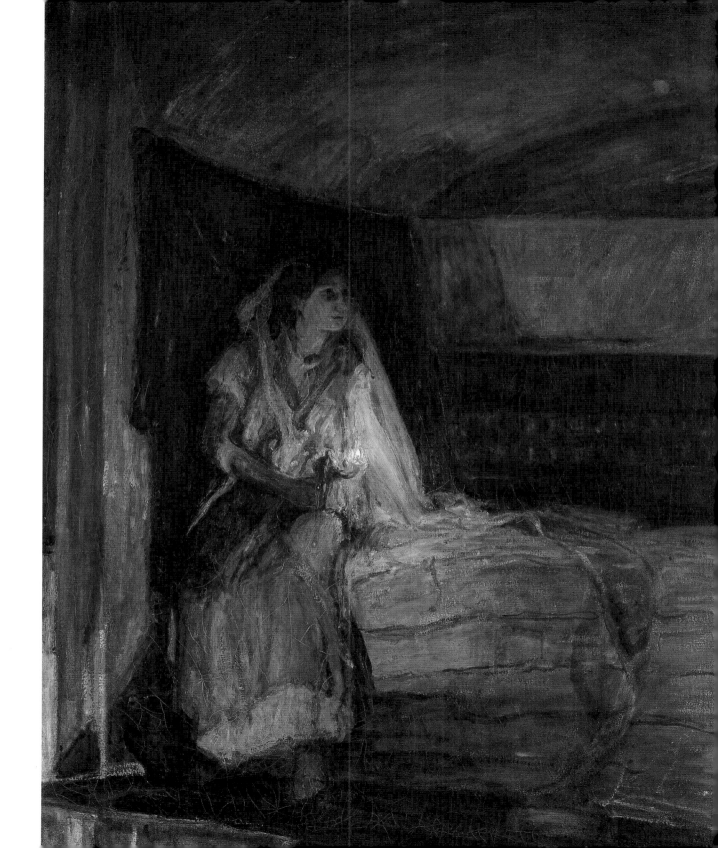

HENRY OSSAWA TANNER

1859–1937

Salomé

about 1900, oil
116.5 x 89.4 cm
Smithsonian
American Art
Museum, Gift of
Jesse O. Tanner

Magically emerging from lapis lazuli shadows, Salomé emits a ghostly glow. The diaphanous folds of her gown barely skim her lush body, heightening her dangerous eroticism. The femme fatale emerged as a frequent subject for art, literature, and opera at the end of the century, in America as well as in France, where Tanner, of African, English, and Native American descent, had settled in 1891 to escape prejudice. From 1897 to 1898, Tanner traveled the Holy Land, taking inspiration from the ancient sites for the religious works that he loved. Falling under the spell of the symbolist aesthetic, an approach that emphasized feelings and imagination over realistic representation, Tanner chose a palette of moody, jeweled hues of blue and gold to create a mysterious, disturbing setting. Within that strange, indeterminate space, he conjured up the sensual evil of a young seductress, whose dances induced in King Herod such a frenzy of arousal that he accorded her the head of John the Baptist.

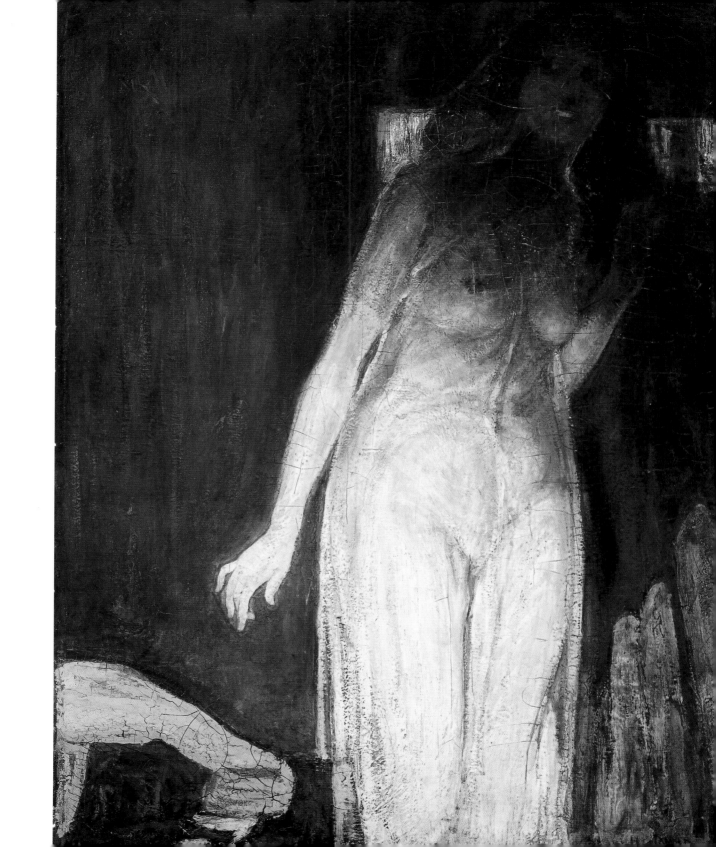

ABBOTT HANDERSON THAYER

1849–1921

Angel

1887, oil
92 x 71.5 cm
Smithsonian
American Art
Museum, Gift of
John Gellatly

Angel may have been the first in a series of winged figures painted by the artist. Thayer never offered an explanation for his enigmatic angel paintings, though they may have been symbols of hope after his first wife died in 1891. Thayer's twelve-year-old daughter, Mary, oldest of his three children, posed for the figure, her graceful form draped in a classic Greek chiton. Thayer attached the wings to a board, which in turn was nailed to a support, allowing the child to pose in front of it without the weight of the prop.

Thayer later placed his winged effigies over landscapes, perhaps as guardians of the New Hampshire nature he loved so much. The wings allowed him to lift his eloquent figures "out of the commonplace" and recall a more innocent and pious past. But *Angel* also captures the contradictions of the era. Belying the materialism of the Gilded Age on the one hand, it was set like a jewel in a glorious gilded wood frame designed by architect Stanford White.

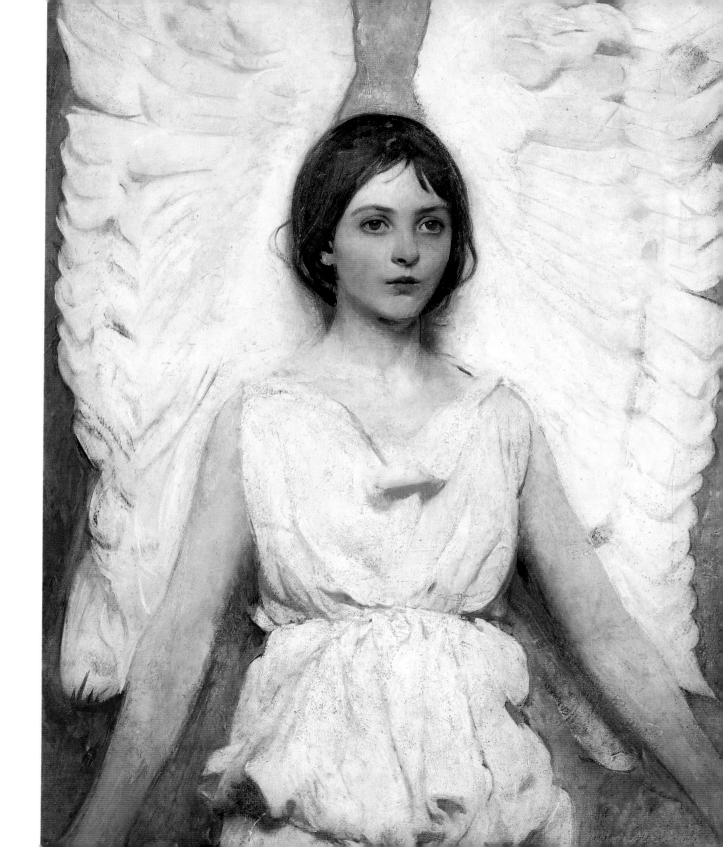

ABBOTT HANDERSON THAYER

1849–1921

Roses

about 1896, oil
56.5 x 79.7 cm
Smithsonian
American Art
Museum, Gift of
John Gellatly

"Beautiful roses, Thayer," remarked the painter Thomas Dewing, "but why did you put them in an ash barrel?" In fact, the choice of an earthenware jar only enhances the organic beauty of the pale pink blossoms. A symbol of love and beauty in the Victorian era, this still life is both an offering of beauty to the viewer and a subtle and atmospheric decorative object.

Thayer carefully delineated the petals, stems, and leaves, allowing the ledge and the pinkish beige background to remain sketchy. Deeply attached to the land and to the sanctity of all living creation, he scrutinized and defined each individual blossom, as if by studying its form he could reveal its inner essence. Amid the splendor of the Gilded Age, contemplative floral still lifes such as this never lost their appeal. In its poetic quietude, subtle color, and delicate brushwork, *Roses* captures a moment in time, crystallizing the transience of life in art.

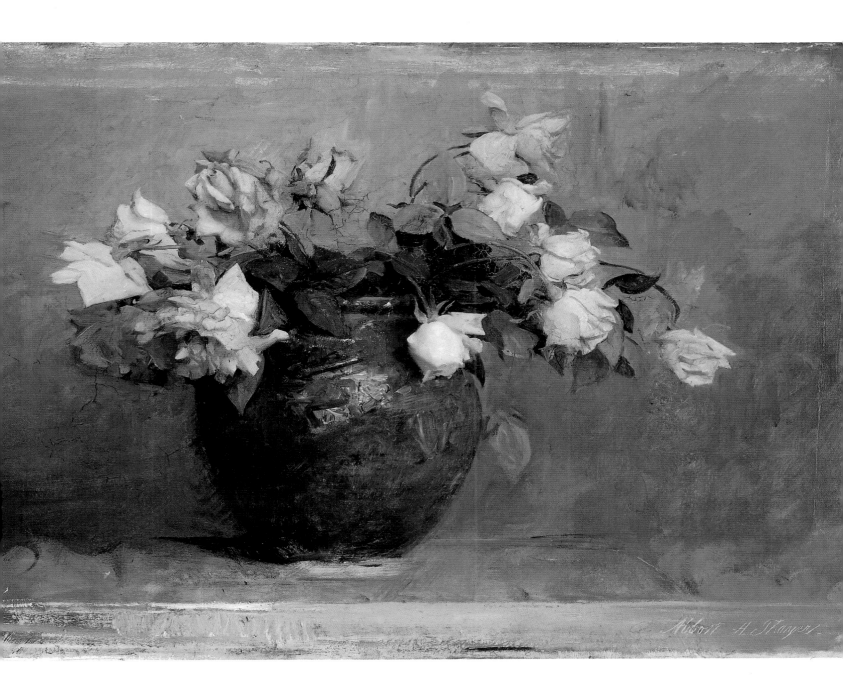

ABBOTT HANDERSON THAYER

1849–1921

The Stevenson Memorial

1903, oil
207.2 x 52.6 cm
Smithsonian
American Art
Museum, Gift of
John Gellatly

Angels appear frequently in Thayer's work, and this memorial to Robert Louis Stevenson derives from the artist's familiar lexicon of metaphors for the spiritualization of everyday life. By adding wings to the model, a servant girl to the Thayer household, the artist transforms the composition into an abstract image of mourning. The word "Vaea," inscribed on the rock, and the palm tree refer to the mountain in Samoa where Stevenson was buried.

Like Augustus Saint-Gaudens, Thayer found Stevenson's tumultuous life and tragic, early death fascinating, and he felt compelled to pay him this tribute some nine years after the writer's death from tuberculosis. The great spread of feathers adorning the figure also refers to the painter's love of birds, while adding a beautifully decorative note to the composition.

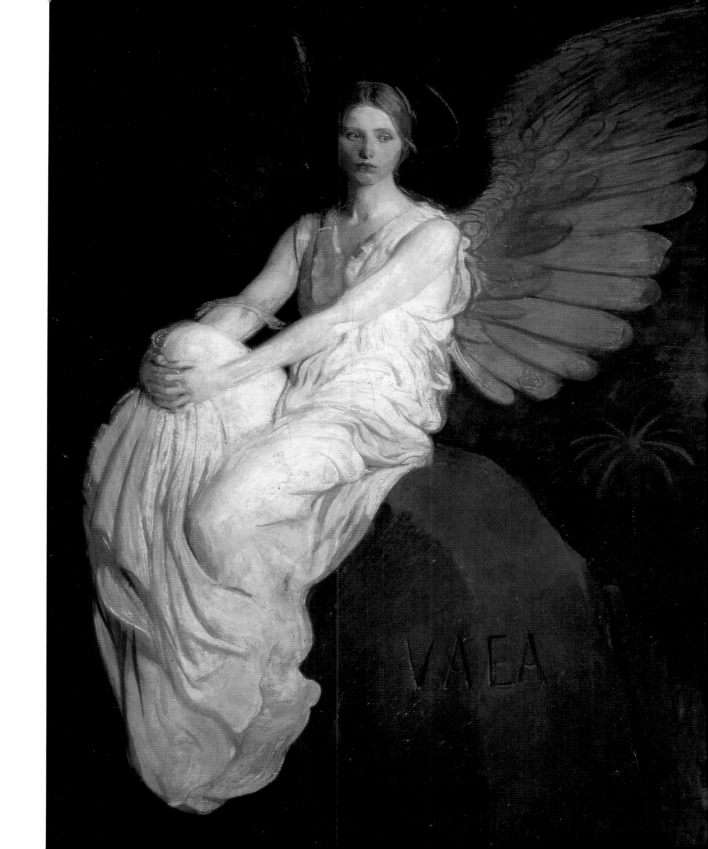

Virgin Enthroned

1891, oil
184.3 x 133.2 cm
Smithsonian
American Art
Museum, Gift of
John Gellatly

When *Virgin Enthroned* was exhibited in 1892, critic Clarence King claimed that "there ought to be buckets under it to catch the dripping sentiment." But other viewers appreciated its "simplicity, dignity, serenity and nobility of old Italian art," so much in step with the era, often called the American Renaissance. Thayer's own children posed for their father: Mary is flanked by Gerald on her left and Gladys on her right. A certain poignancy suffuses the work. At this time, his wife Kate was suffering from the acute mental illness that would claim her life the same year. Thayer immersed himself in painting, taking to it "all these dark months as to drink," he wrote, and in so doing, achieved what one contemporary critic called the "realisation of ideal womanhood . . . a poem of life . . . of family love."

Faced with what he considered the garish affront of avant-garde art, Thayer embraced an idealized past and eternal values in this Renaissance altarpiece format; in its exquisite opaline greens, blues, and purples lie hints of Titian. Although the painting's mood was traditional, critic Mariana van Rensselaer felt that in its "conception and execution—in its types, its colors and its treatment—it is distinctly modern."

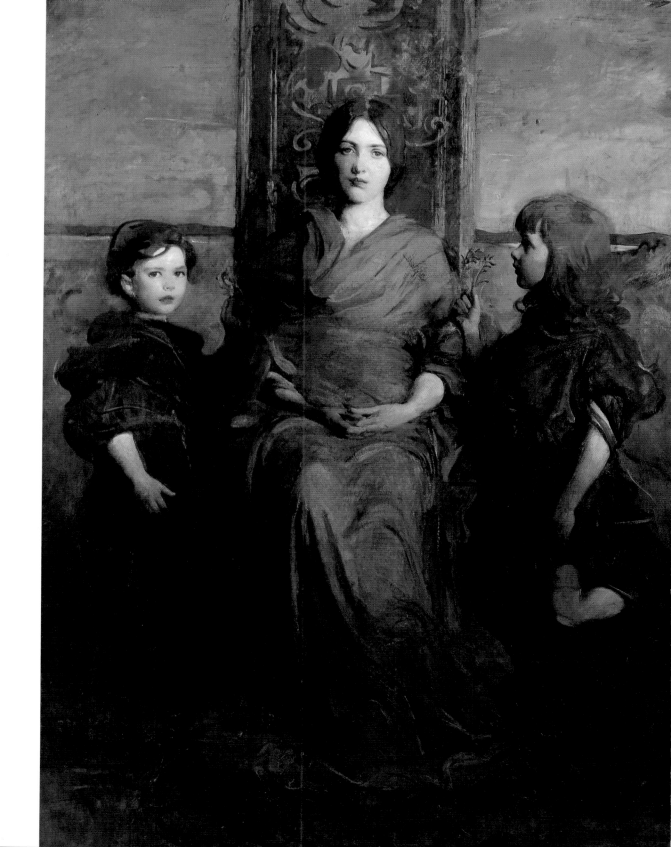

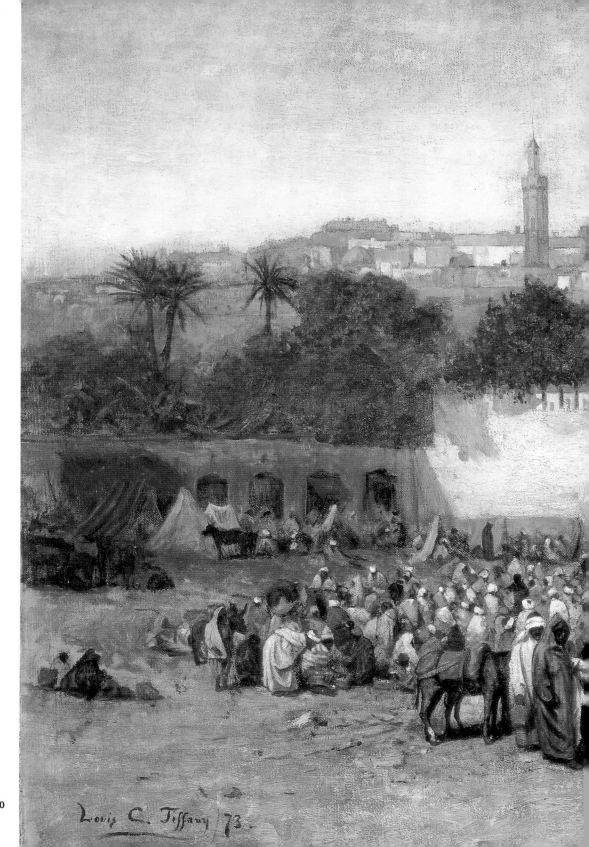

LOUIS COMFORT TIFFANY

1848–1933

*Market Day
Outside the
Walls of Tangiers,
Morocco*

1873, oil
81.6 x 142.3 cm
Smithsonian
American Art
Museum, Gift of the
American Art Forum

ELIHU VEDDER

1836–1923

The Cup of Death

1885 and 1911, oil
113.9 x 57 cm
Smithsonian
American Art
Museum, Gift of
William T. Evans

In *The Cup of Death,* Vedder created the perfect setting for the mysterious moment of departing earthly life. Azrael, the angel of death, leads a young woman through the reeds to the dark river while gently, persuasively, holding a cup of poison to her mouth. As frightening as the subject may be, the painter intended to depict death in a gentle manner, a painless immersion into dark waters, guided by a merciful spirit. His palette of gray and cinnamon, pink, white, lilac and yellow, and blue and green, enhances the somber, ghostly tone, in consonance with the awesome majesty of his theme. Vedder skillfully combined the muted hues characteristic of late-nineteenth-century art with references to neoclassical sculpture, as seen in the great wings and clinging draperies.

The picture was inspired by a design for an illustrated edition of the *Rubáiyát* of Omar Khayyám, a collection of epigrammatic observations on life by the twelfth-century Persian astronomer. The image represents a verse from the volume, suggesting that one not "shrink" from the angel when he offers the "darker Drink." The moody subject suited Vedder's temperament, allying him with the more mystical artists of the period.

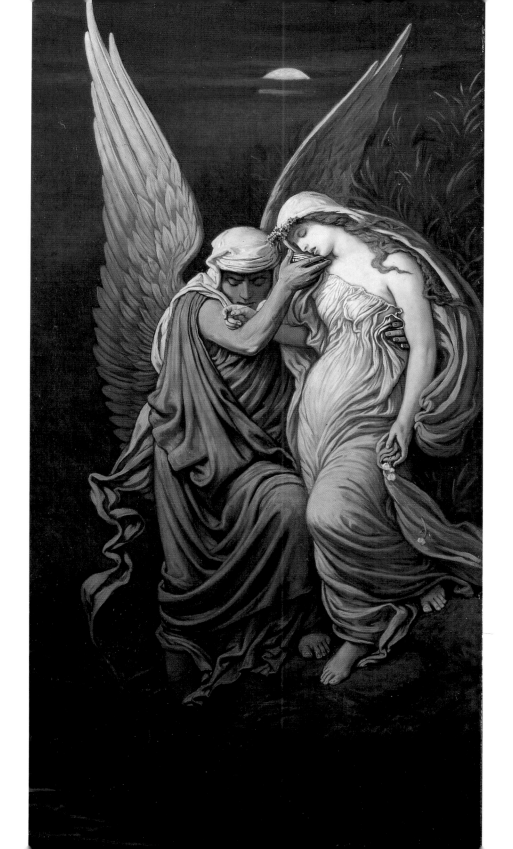

ADOLPH A. WEINMAN

1870–1952

Descending Night

Rising Sun

Smithsonian
American Art
Museum
Gift of Mrs. Adolph
A. Weinman

The Panama-Pacific International Exposition of 1915, held in San Francisco, celebrated the completion of the Panama Canal, which linked Atlantic and Pacific, Europe and Asia. The planners designed the fairgrounds to reflect the great walled cities of the Eastern Mediterranean and, at the center in the Court of the Universe, two fountains with enormous columns graced the plaza. Atop the columns stood casts of these two eloquent sculptures.

In keeping with the philosophical and artistic aspirations of Americans before World War I, *Descending Night* carried symbolic overtones, described by the exposition's official publication as "a gorgeous woman's figure just alighting, the brooding face and folding wings more than suggestive of dusk and starlight"; *Rising Sun* is described as "a joyous youth a-tiptoe, ready to commence his morning flight."

Weinman originally modeled the almost life-size works in reinforced plaster for the exposition, then cast these reduced bronze versions for placement in a private home. One pair of bronzes was later presented to the White House, where they graced the West Wing sitting room during Herbert Hoover's administration.

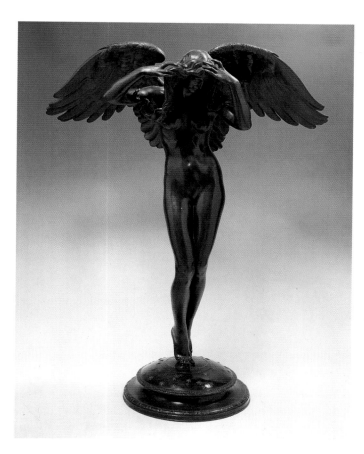

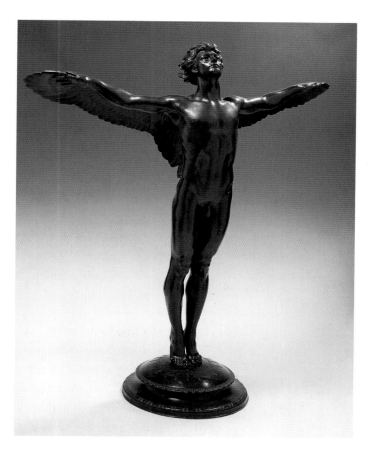

modeled about 1915, bronze

143.5 x 117.5 x 61.6 cm

1914, bronze

144.1 x 134 x 50.8 cm

JOHN FERGUSON WEIR
1841–1926

Roses

1898, oil
50.8 x 76.5 cm
Smithsonian
American Art
Museum, Gift of
Miss A. M. Hegeman

In the Victorian era, hundreds of books were published on the symbolism of flowers, and roses stood for love and beauty. Through the poses and attitudes of each rose, Weir's painting tells us a story, of love killed, love hopeful, love triumphant, love confused. Assembled loosely in a clear glass vase, the roses twist in all directions. Several have fallen to the side of the shallow bowl onto the table, and at left a blossom, broken off from its stem, lies forlornly by itself.

When *Roses* came as a gift to the museum in 1942, it inspired an entire newspaper article. "It is an exquisite work," the critic enthused, "well composed and so subtly rendered that it seems scarcely to belong to the things of this world." Weir complemented the image's narrative overtones by veiling the scene with a gentle glow, prompting the critic to further observe that "the atmosphere by which [the roses] are surrounded is as elusive as a disembodied spirit." The soft illumination and the artist's sensitive paint handling enhance the evocative quality of this deceptively simple still life.

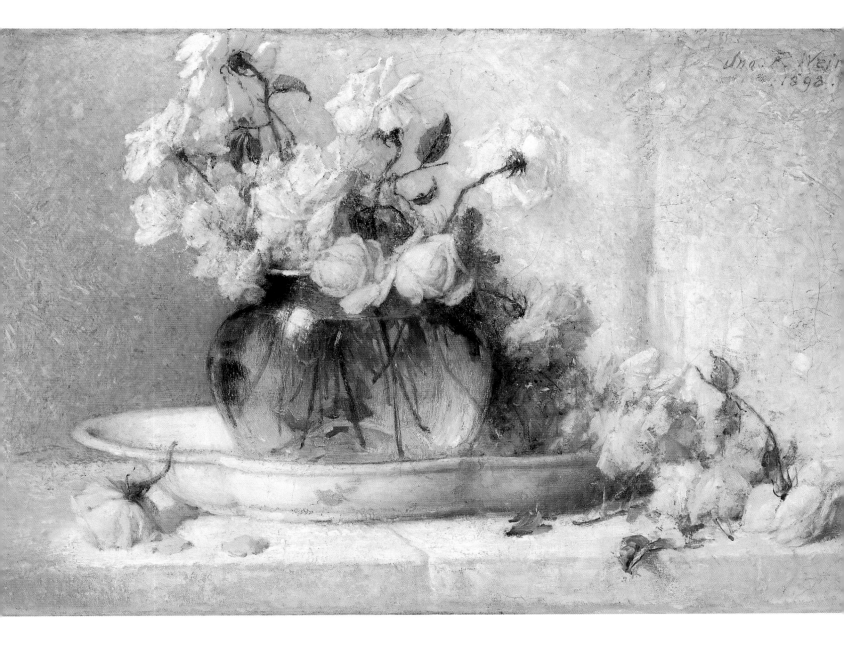

IRVING R. WILES

1861–1948

Russian Tea

about 1896, oil
122 x 91.6 cm
Smithsonian
American Art
Museum, Gift of
William T. Evans

Three elegant women and a little girl anticipate the hot tea that brews in the great brass samovar. Wealthy, beautifully clad, they gather in a richly appointed interior where lamps with gaily striped shades flank a gilt-edged mirror. For the privileged, the Gilded Age of the 1880s and 1890s represented a moment of untold wealth, of pre-income tax lavishness never before witnessed in this country. After amassing enormous fortunes in such realms as real estate, railroads, and mining, newly wealthy individuals decided it was time to spend, conspicuously and extravagantly. With loose, caressing, impressionistic brush strokes and a dash of French-influenced flair, Wiles captures this intimate glimpse of an era's leisured opulence.

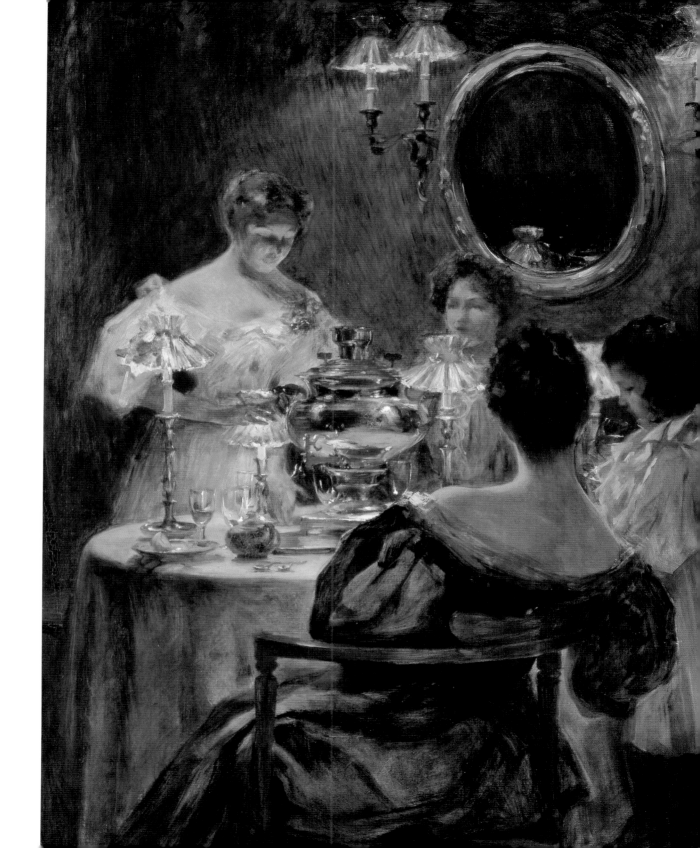

Index of Titles

The Adams Memorial, Augustus Saint-Gaudens, 76

Adoration of St. Joan of Arc, J. William Fosdick, 28

Alfred, Lord Tennyson, William Ordway Partridge, 66

Angel, Abbott Handerson Thayer, 92

Bohemian Bear Tamer, Paul Wayland Bartlett, 10

The Cup of Death, Elihu Vedder, 102

Descending Night, Adolph A. Weinman, 104

Diana, Augustus Saint-Gaudens, 78

Elizabeth Winthrop Chanler, John Singer Sargent, 82

Farm Interior: Breton Children Feeding Rabbits, William Henry Lippincott, 54

Fisher Girl of Picardy, Elizabeth Nourse, 64

The Girl I Left Behind Me, Eastman Johnson, 46

High Cliff, Coast of Maine, Winslow Homer, 40

Idle Hours, H. Siddons Mowbray, 62

Illusions, Henry Brown Fuller, 32

Improvisation, Childe Hassam, 36

An Interlude, William Sergeant Kendall, 50

Jonah, Albert Pinkham Ryder, 70

Lamentations over the Death of the Firstborn of Egypt, Charles Sprague Pearce, 68

Lighthouse Beach, Annisquam, Hugh Bolton Jones, 48

Lord Ullin's Daughter, Albert Pinkham Ryder, 72

Magnolia, Charles Walter Stetson, 86

Man with the Cat (Henry Sturgis Drinker), Cecilia Beaux, 12

Market Day Outside the Walls of Tangiers, Morocco, Louis Comfort Tiffany, 100

Mary, Henry Ossawa Tanner, 88

Moonlight, Indian Encampment, Ralph Albert Blakelock, 16

Mother and Child (Lady Shannon and Kitty), James Jebusa Shannon, 84

Music, Thomas Wilmer Dewing, 22

Novembre, Etaples, Walter Gay, 34

Oriental Interior, Frederick Arthur Bridgman, 18

A Reading, Thomas Wilmer Dewing, 20

Rising Sun, Adolph A. Weinman, 104

Robert Louis Stevenson, Augustus Saint-Gaudens, 80

Roses, Abbott Handerson Thayer, 94

Roses, John Ferguson Weir, 106

Russian Tea, Irving R. Wiles, 108

Salomé, Henry Ossawa Tanner, 90

The Sermon, Gari Melchers, 60

September Afternoon, George Inness, 42

The Sick Child, J. Bond Francisco, 30

Spring Dance, Arthur F. Mathews, 58

The Stevenson Memorial, Abbott Handerson Thayer, 96

Summer, Frank W. Benson, 14

Tree Landscape, Edward Mitchell Bannister, 8

Undine, Chauncey Bradley Ives, 44

Venus and Adonis, Frederick MacMonnies, 56

Virgin Enthroned, Abbott Handerson Thayer, 98

Water Carriers, Venice, Frank Duveneck, 24

William Rush's Model, Thomas Eakins, 26

With Sloping Mast and Dipping Prow, Albert Pinkham Ryder, 74

Woman with Red Hair, Albert Herter, 38

Wreath of Flowers, John La Farge, 52

The Smithsonian American Art Museum is dedicated to the preservation, exhibition, and study of the visual arts in America. The museum, whose publications program also includes the scholarly journal *American Art,* has extensive research resources: the databases of the inventories of American Painting and Sculpture, several image archives, and a variety of fellowships for scholars. The Renwick Gallery, one of the nation's premier craft museums, is part of the Smithsonian American Art Museum. For more information or a catalogue of publications, write: Office of Print and Electronic Publications, Smithsonian American Art Museum, Washington, D.C. 20560-0230.

The museum is also on the Internet at **AmericanArt.si.edu.**